WEBSIGHTS:

THE FUTURE OF
BUSINESS AND DESIGN →
ON THE INTERNET

① ② 3 ④ ⑤ 6 ⑦ 8 ⑨ ⑩

Published by
RC Publications, Inc.
104 Fifth Avenue
New York, NY 10011

Websights: The Future of Business and Design on the Internet
Library of Congress Catalog Card Number 99-074782
ISBN 1-883915-07-4

RC PUBLICATIONS
President and Publisher
Howard Cadel
Vice President and Editor
Martin Fox
Creative Director
Andrew Kner
Managing Editor
Joyce Rutter Kaye
Associate Editor
Todd Pruzan
Associate Art Director
Michele Trombley
Assistant Editor
Robert Treadway III
Permissions Assistant
Kathy Lee

Thanks to Frank Martinez for his legal advice.

Websights is set in CIA-Humdrum with chapter titles and captions in Jens Ans, both faces by type designer Jens Gehlhaar. Subheads within chapters are set in Adobe Akzidenz Grotesk. The faces CIA-Gothic and Odd Job are also used courtesy Jens Gehlhaar.

WEBSIGHTS: THE FUTURE OF BUSINESS AND DESIGN → ON THE INTERNET

WRITERS
STEVE BODOW
CLIVE BRUTON
DARCY DINUCCI
PETER HALL
LAUREL JANENSCH
STEVEN HENRY MADOFF
JOHN MAEDA
ANDREA MOED
RHONDA RUBINSTEIN
CARL STEADMAN

EDITOR
KATHERINE NELSON

BOOK DESIGN
CHRISTA SKINNER

PUBLISHED BY
RC PUBLICATIONS, INC.
NEW YORK, NY

TABLE OF CONTENTS

>

INTRODUCTION:

WEB DESIGN

AND THE

TOTAL USER EXPERIENCE

TEXT: KATHERINE NELSON

What is Web design? The field is vast, encompassing such areas as graphic design, information architecture, advertising and sponsorship, entertainment, and e-commerce. When faced with the task of assembling a collection of writings on Web design, the editors of PRINT magazine were also faced with the following question: What overarching theme can possibly begin to link such disparate design backgrounds, approaches, and attitudes? In my ongoing discussions with the contributors to this book as well as a variety of design professionals, one theme has continued to resurface when they define the role of the digital designer: creating "experiences." Industry observers, designers, and executives alike often describe designing for technology as the act of crafting a compelling user experience.

The idea of experience creation is not merely a new design approach, but rather the result of a fundamental economic shift, according to Joseph Pine and James Gilmore, authors of *The Experience Economy* (Harvard Business School Press, 1999). Pine and Gilmore claim that Western culture, in its current state of affluence, has moved beyond the consumption of mere products and services. More and more, people are paying for such intangible offerings as the creation of memories or fulfillment of fantasies. To support continued economic growth, many American companies, especially those in the service sector who already deliver a more "intangible" product (e.g., dry-cleaning, baby-sitting, food service) have begun to shift their focus away from the product itself to how the product is used. (For example, a clothing manufacturer might develop a marketing strategy around how a specific piece of clothing would be worn, cleaned, transported during a vacation, or stored in the off-season.) "Experiences represent an existing but previously [under-recognized] genre of economic output," write the authors. "Information is not the foundation of the 'New Economy' because information is not an economic offering. Only when companies constitute it in the form of information services—or information goods and informing experience—do they create

economic value." Offering myriad examples from theme restaurants to luxury travel, Pine and Gilmore argue that "companies stage an experience whenever they engage customers, connecting with them in a personal, memorable way."

Granted, when designers employ the term "experience" to describe Web design, they could be describing almost any number of consumer interactions, from TV to broadcast to print. However, of all these media experiences, it is the Web that is the most inherently active in its engagement with consumers. Craig Kanarik, self-titled "chief scientist" and head of the prominent digital design firm Razorfish, says, "I don't think that people make the same commitment to the other forms of media that they do to interactive or digital media. With TV, for example, it's a much more passive experience. People will leave it on as background noise while they walk around the room. On the Internet, you certainly don't have that type of behavior and you constantly run the risk of losing people's attention." Joel Hladecek, chief creative officer of Red Sky

Interactive, agrees that a successful Web experience must not only inform users but also thoroughly engage them. "Traditional advertising is about communicating the notion of value to a target group," says Hladecek. "Whereas in the online space, you have to provide value immediately. It's not enough to communicate it."

The idea of the immersive user experience begins with the creation of an environment that can be uniquely tailored to each individual. Mark McCabe, a designer at ePlanet, likens a compelling digital experience to an evening at the movies: "You leave the theater with a story, a fable about your experience. It's a jigsaw of individually created moments. The theater, the film, the chewing gum on the floor, parking the car, the traffic jam, and the grumpy attendant are all fundamental components of your experience." McCabe makes the point that it is the variables as well as the fixed elements in an interaction that comprise a participant's experience. The movie itself is a structured, contrived component of the occasion; the chewing gum is not. Both elements are ingredients of the overall environment within which the user's personal choices will drive his or her specific narrative.

How do designers allow for the kind of variables that McCabe describes while still presenting a meaningful and consistent client message? What exactly is the cyber-equivalent of chewing gum on the floor, that quirk which makes an experience more compelling and unique? Gilmore and Pine tie the idea to consumer psychology: "[An experience-provider] no longer offers goods or services alone but [a] resulting experience, rich with sensations, created within the customer. All [more traditional] economic offerings (e.g., goods, commodities, and services) remain at arm's length, outside the buyer, while experiences are inherently personal. They actually

occur within any individual who has been engaged on an emotional, physical, intellectual, or even spiritual level."

Creating a seamless user interaction, one driven from both within and without the consumer, is currently of major concern to the designers of hardware interfaces. In product design, physiological information is often used as a model to develop what are termed "smart" user interfaces. "The challenge for the designer is to create an experience that may be unique to the user, but that is also dependent on his or her life experience," says Geoff Smith, a scientist at Interval Research, the vanguard technology think tank in northern California. Smith gives the example of a car radio melding to a specific user's needs at a specific moment in time: "The turning of the station-knob sends information to the micro-controller, where it decides the volume. It may also receive data from the speedometer, thereby allowing the wind rush to be taken into consideration when deciding an appropriate volume. So, as devices gather information from a broader range of sources, product designers can create more integrated experiences." The idea is not to create things that blink, honk, or beep, but experiences that meld seamlessly with the momentary and unique needs of the individual user.

So what about the Web, the least visceral and most virtual of media? Hladecek, whose design team touts the title "experience engineers," presents a scenario of the virtual world based on personality and psychology. "You populate an online environment with objects, be they buttons or characters, that have a certain kind of behavior. You are essentially assembling the makings of a great story, not the story itself. Because, ultimately, it's the user who lives on the playhead of the experience. It's the path the user chooses to take that becomes the story." While designers give up control over structure and sequence, they gain control by providing a set of behavioral guidelines. "The only control mechanism that you have as the creator of this space is the self-motivation of the audience," says Hladecek. "You can't tell them what to do. They have to decide themselves. You focus instead on how rich the environment is. You focus on the depth of your characters. What are their triggers? How do they respond? How do they play off one another? Then you let the user play along with them."

When exploring the total user experience, why should we limit our discussion to the Web? In terms of constructing engaging situations, isn't the idea to leverage a brand across all media, thus creating the ultimate brand immersion? Says Kanarik: "Say you are Nike and you want to show somebody a TV commercial. If the TV could morph physically, like the Sony logo changes into a Nike logo during the commercial, for example, then you've got the idea. Better yet, if the whole room turned into a Nike store during the commercial, we would love that. The intention is to build up the interaction between the consumer and this metaphysical brand essence." Kanarik says that his team at Razorfish had actually been "fighting" the perception of their firm as a Web-design company. "I don't care whether the experience is on the Web, on TV, or in plastic. It's not about making logos and pictures and text. It's about crafting the user's reaction," he says.

So where does the broader perspective leave us? Is it myopic, as Kanarik suggests, to explore the particular potential of the Web during a time of increasing sophistication in the technology of many other disciplines? He has a point. Creating Web sites is indeed only one component of the overall interface between brand and consumer that can be manifested cross-platform on TV, in print and product design, on the Web, or in almost any media combination conceivable. The issue comes down to another key idea: the craft of design. The content of *Websights* harks back to the fundamental notion that expertise is built from the ground up. In order to create an optimal user experience, we must first analyze its most fundamental components. In breaking down the interactive paradigm, from the nuances of digital typography presented by Clive Bruton in Chapter 3 to the subversive navigation explored by Steven Henry Madoff in Chapter 6, designers can begin to understand the potential of the total user experience. After that, where to draw the line is defined only by the self-prescribed limits of each individual designer.

—Katherine Nelson, Editor

From a server in love

volumeone
visual communicatio

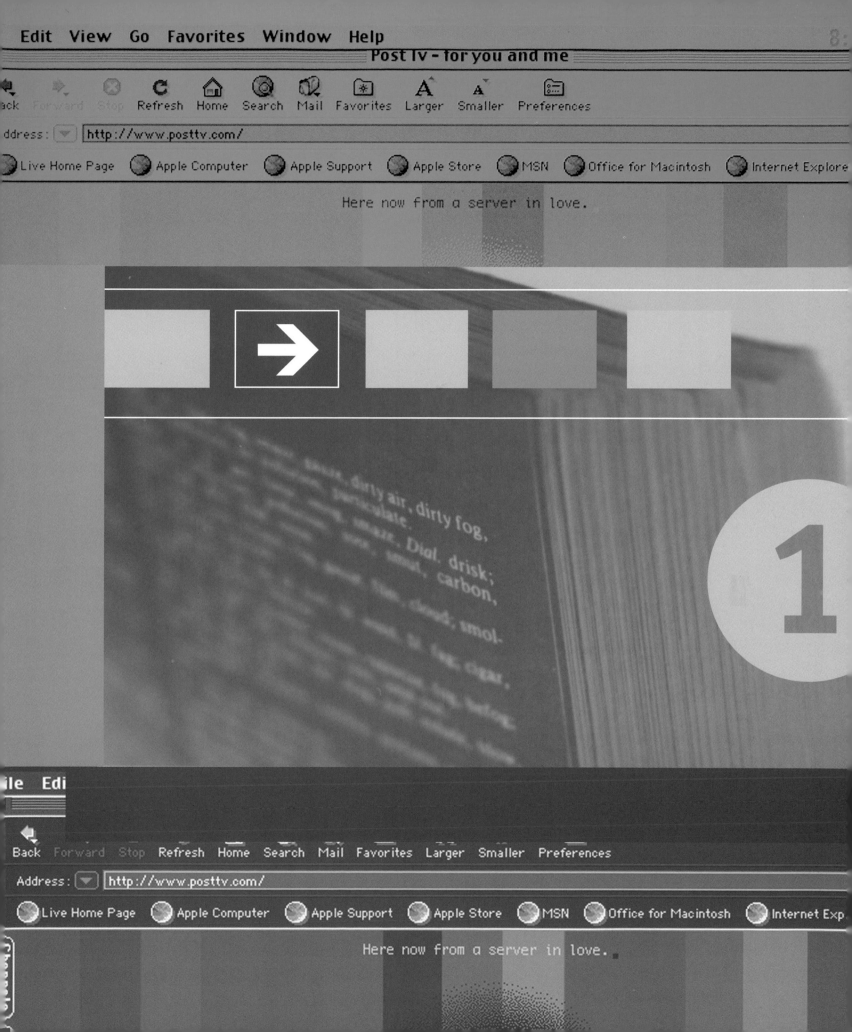

ROLE REVERSAL:

THE WEB AS METAPHOR

FOR TRADITIONAL MEDIA

TEXT: RHONDA RUBENSTEIN

It was 1984, the year imagined by Orwell and engineered by Apple. William Gibson published a novel titled *Neuromancer* and coined the term "cyberspace," while Paul Brainerd founded a company called Aldus and invented "desktop publishing."

One could claim that 1984 saw the beginning of many things, but of particular significance for the development of Web communications a decade later, it saw the introduction of the first computer metaphor. The new Macintosh screen became a desktop, littered with visual representations of physical objects. Gone were the pointless and clickless screens of command-line program code. Instead, one found bitmapped icons of folders that opened, a smiling face when the computer booted up, a frowning one when it didn't, and a cute bomb when it crashed. This iconic vocabulary made unfamiliar technology a little more familiar and a lot more user-friendly (an idea that had previously enjoyed little market value in computing circles).

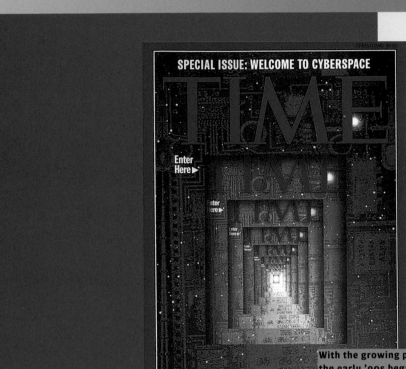

SPECIAL ISSUE: WELCOME TO CYBERSPACE

TIME

Enter Here ▶

With the growing public awareness of the Web, the early '90s began to see a replication of the cyberexperience in print.

: // ://www.
: // ://www.
: // ://www.
: // ://www.
: // ://www.
: // ://www.
: // ://www.
: // ://www.
: // ://www.
: // ://www.
: // ://www.
: // ://www.
: // ://www.
: // ://www.
: // ://www.
: // ://www.
: // ://www.
: // ://www.
: // ://www.
: // ://www.
: // ://www.
: // ://www.
: // ://www.
: // ://www.
: // ://www.
: // ://www.
: // ://www.
: // ://www.
: // ://www.
: // ://www.
: // ://www.

The use of graphic metaphors to contextualize and orient the unaccustomed was echoed years later as the entirely new medium known as the Web developed. Except this time, if confused users arrived at a Web site, there was no manual to read. So the Web, which began by appropriating metaphors from conventional media, soon evolved its own language. Interestingly, this visual language took on a cultural resonance that began to influence and even transform more traditional media in unexpected ways. This chapter will explore the metaphors of old and new media that have emerged in the rapid span of three generations of Web design.

Not long after 1984, computers became personal at home and inescapable at work. This reported shift towards the so-called paperless future killed many a tree while launching a highly profitable category of computer magazines and books. Magazines struggled with the visual representation of a less tangible world. Metaphoric illustrations of data compression, memory storage, and software development were soon overtaken by surreal moments of digitalia, aided and abetted by the development of drawing programs. But it was the graphic simplicity of the Macintosh windows, tools, and icons that provided the lasting visual fodder for new technology references. From the design of *MacUser*, launched in 1985, which featured headings of screen fonts in pull-down menus and bitmapped icons, to a *Time* magazine special issue (Vol. 145, Issue 12, spring 1995), titled "Welcome to Cyberspace" with a Escheresque cover of infinite circuit boards, a language of graphic clichés had emerged.

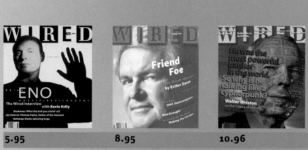

5.95 8.95 10.96

3.96
By the mid-'90s, the fluorescent covers of *Wired*
magazine embodied "computer cool" on the printed page.

a *WIRED* WORLD When *Wired* launched in 1993, the magazine chose another aspect of the digital revolution for its look and feel: the vibrant colors of the light-emitting computer screen. *Wired* took the fluorescent inks from the covers of women's magazines and slathered them, in all their six- or eight-color glory, throughout its pages. The ensuing debates about legibility only increased the magazine's popularity and made fluorescent colors and cross-processed photography visual shorthand for "computer cool." But, at the time, even *Wired* wasn't quite up to Internet speed; the back-page columnist was introduced with the note, "Message 1. From: Nicholas Negroponte <nicholas@internet>." The folly of that impossible email address would only have been recognized by the few (well, million) people connected to the Internet at the time. Marc Andreessen would have been one of them. The now-famous, then-22-year-old undergraduate was in the process of creating Mosaic, the first browser to view graphics and play sound through the Internet. Unbeknownst to even the government, this, along with the introduction of the HyperText Markup

Language (HTML), was to turn the vast computer network into a medium. It was a medium that eager IT professionals would soon be busy creating Web sites for, following the Unix hierarchical structures known and loved by computer programmers.

existing METAPHORS On the Web, page settings and typographic controls were determined by the user and there was no precedent for how things should be—no rules to follow or break. Furthermore, there was no way for the audience to know what was behind the screen. The challenge was to organize and represent information in such a way that its scope could be easily understood. The solution: to employ design metaphors from existing media. Employing a familiar communication structure, like a magazine, book, or TV, immediately offered a frame of reference and a grasp of organization. Even the language used to refer to the Web itself was based on metaphors: terms from print described content (Web publishing begins with creating "pages"), and travel references explained structure (a "welcome" screen appears as users enter a site; "maps" help the user "navigate" the further reaches of the World Wide Web and return "home" again).

photo: © Till Krautkrämer, 1999

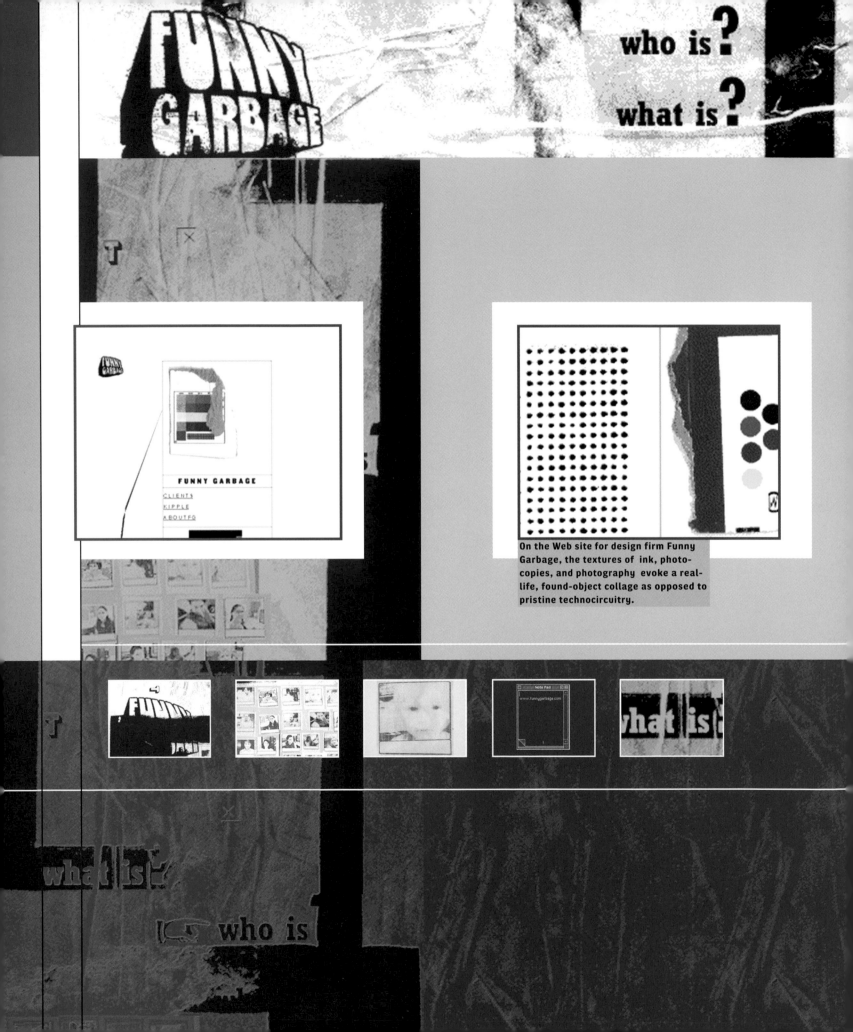

On the Web site for design firm Funny Garbage, the textures of ink, photo-copies, and photography evoke a real-life, found-object collage as opposed to pristine technocircuitry.

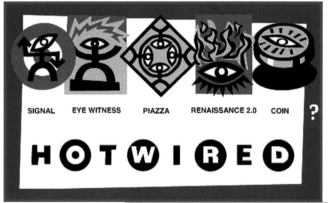

The first "front door" of HotWired circa 1994. The designers' innovative use of iconography had mixed results; users were enticed by the cryptic symbols but got lost easily.

The graphic metaphors appearing on Web sites were directly related to the media forms favored by their creators. Technologists designed sites that alluded to the early days of supercomputers. There were 3-D logos, beveled buttons, drop shadows, and lots of green and black to remind everyone that what they were doing was like using computing machinery, except the machine sat on your desk, accompanied by a TV screen and a typewriter keyboard. There was also textured paper, marbled surfaces, patterned backgrounds, and other random reproductions of a 3-D world on the Web, simply because there could be. (Thank you, Kai, for those Power Tools.) Often, today's Web designers, such as New York's Funny Garbage, prefer paper smudges, hand-rendered type, and photocopied collages to contrast with the slick surface of technology. Somehow, the imperfections of old technology (ink on paper) seem infinitely more charming than the errors of the new (missing plug-ins, broken GIFs).

ICONOGRAPHY Following the overwhelming success of the Mac desktop, early Web sites often used icons to extend their chosen metaphor and establish a unique identity. In 1994, HotWired's first front door featured one large image map with five graphic icons referring to vague sections such as "Signal" or "Renaissance 2.0." Though HotWired deliberately steered away from print metaphors, it took faith, patience, and

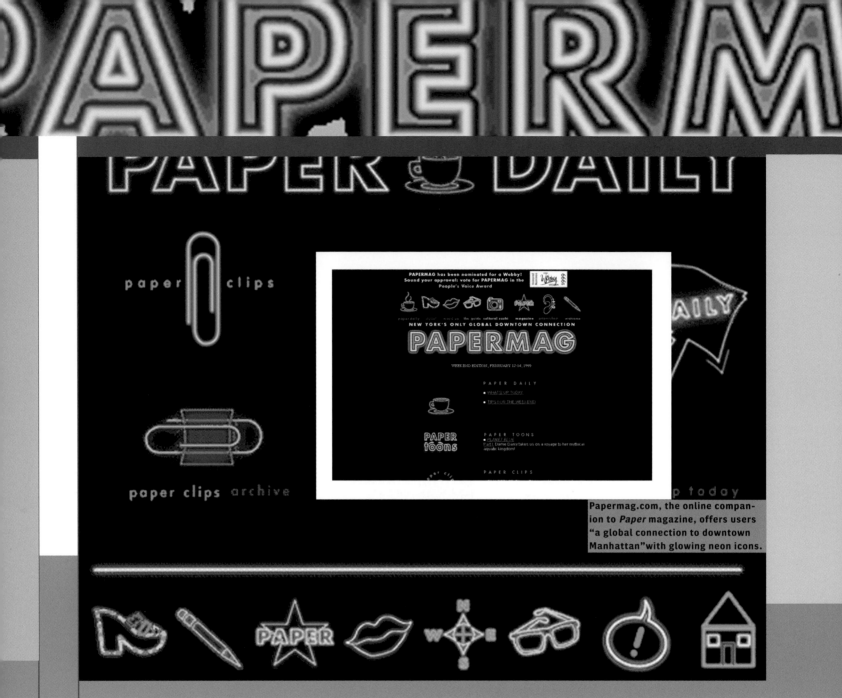

Papermag.com, the online companion to *Paper* magazine, offers users "a global connection to downtown Manhattan" with glowing neon icons.

several clicks to arrive at the content. The use of the icon as an organizational device has far from disappeared from Web design. A current example can be seen at Papermag.com, the online companion to New York City's hip, downtown magazine *Paper*. Glowing icons set against a black glowing screen evoke a New York night guided by the optimism of the next neon sign.

old media
MEETS NEW
In New York in 1994, Time Inc., the first big media company to arrive on the Web, launched the Pathfinder Network. In an extravagant undertaking, the company tried to repurpose as much content from as many of its magazines as possible. The behemoth site became an oft-cited example of old media not understanding new media and paying dearly for it. But without large corporations sinking huge sums into new technologies—and without innovative individuals experimenting in their garages—there would be little progress. (For every Pathfinder, there is a *Suck*.)

> www.papermag.com
> www.pathfinder.com
> www.suck.com

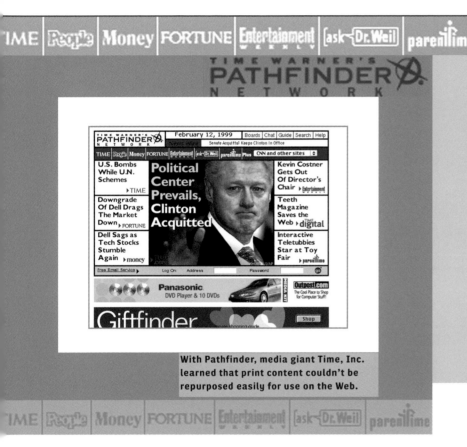

With Pathfinder, media giant Time, Inc. learned that print content couldn't be repurposed easily for use on the Web.

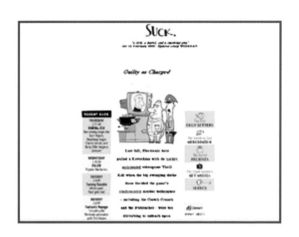

***Suck**, conceived of by two moonlighting HotWired employees, was an early, low-budget example of a Web site finding a dedicated audience.*

pages and
TABLES
As professional designers migrated to the Web, they brought centuries of print design expertise to the screen (very little of it relevant). Designers often favored the printed-page metaphor with its visual table of contents, precisely designed section headings, and editorially directed flow of information. Compared to the usual drab pages of HTML, the original 1995 Discovery site, with its intricate windows combining type and illustration, was like a precious book-title page. The complexity of the site was possible because of the recent introduction of tables, described in a HTML manual as "the most interesting thing to hit the Web since forms." Though these tables had been created by engineers to display mathematical data, their functional resemblance to the again-fashionable grid revolutionized Web-page design. The manipulation of these cells into organizational structures for content encouraged more pagelike design on the Web. And

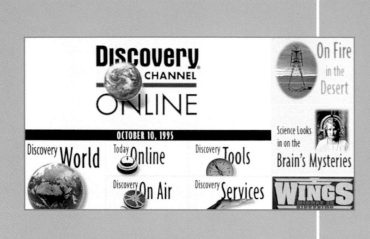

The 1995 Discovery site (a prototype home-page above) employed what-was-then a unique use of tables to organize content.

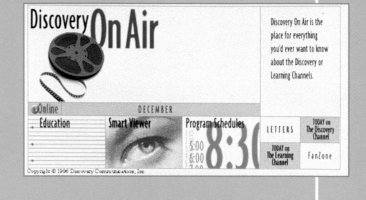

A sketch of the "On Air" section displays image-laden content. Although a pokey download, the site won many design awards.

Employing direct translations of print elements such as page numbers and section headers, *Slate*'s clean interface was a surprising success.

A detail from *Slate*'s table of contents, one of the magazine's analog features that holds its own in cyberspace.

> www.discovery.com
> www.slate.com
> www.salon.com
> www.word.com

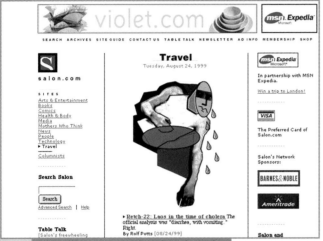

The art directors at *Salon* view the Web as an unlimited source of white space.

The vastness of cyberspace allowed the editors of *Word* to run articles without cuts for length.

while the Discovery site looked good on paper, so to speak, the image-heavy screens and top-heavy hierarchy decidedly slowed down the experience of the site. The creation of frames, tables, and style sheets was the beginning of a second generation of Web sites. This new wave of Web design was about the latest technology, with plug-ins like Java and RealAudio being developed specifically for the Web. But while bandwidth increased, so did file sizes, maintaining a steady pace of frustration.

Web ZINES In 1996, *Slate* entered the world of online politics from a particularly off-line angle. *Slate* followed the literary lead of *Word* and *Salon*, which were launched the previous year using the structure of print magazines. *Salon*'s very traditional design even featured the designer's coveted commodity, white space. In fact, unlimited space was seen as the primary advantage of Web publishing. *Word* had been created as the writer's revenge: Ideas and writing would not have to be edited for length or clarity. And *Slate*'s editor, who arrived with an extensive print background and little familiarity of the Web, launched Microsoft's e-zine with 2000-plus word articles. The initial laughter subsided as *Slate* progressed to produce a cleanly designed site of substantial news summaries and features. Its analog organization included a table of contents, a numbered page slider, modern section headers, and a singular floating column of text, all of which could be accessed using another print convention: a $19.95 annual subscription. (The fee was later rescinded.)

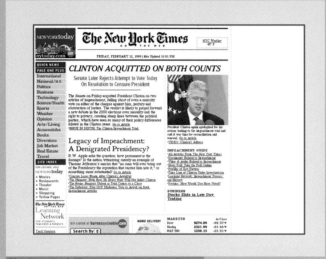

The New York Times on the Web retains the template formula of its printed counterpart. The layout has proven to work well for speedy news updates.

paperless
NEWSPAPERS
When considering breaking stories and the timeliness of information, the newspaper is the print medium most closely associated with the Internet. *The New York Times*'s site is a direct brand translation from newsprint to screen, from its Old English logo and fonts to the vertical gray rules separating the columns. Its structure is virtually identical to many other news sites: a narrow left column site index, a larger center column showcasing the main news, and a column on the right with additional features. This architecture can also be seen with minor variations on c|net, E!Online, MSNBC, and WiredNews, among others. The conformity of these sites parallels the print world, where newsmagazines such as *Time*, *Newsweek*, and *U.S. News and World Report* have practically indistinguishable formats (red banners signaling each section, three-column grids framed by rules, and consistently sized headlines and subheads). The news site genre has evolved to such a predictable formula that it is now surprising to arrive at a news site like PBSOnline that doesn't cram its entire contents into the top corner of the front page, above the fold, as it were. Of course, once there's an established ideal, there's the potential for parody. *The Onion* adeptly uses the conventions of the online news structure to appear more truthful than satirical.

> www.nytimes.com
> www.eonline.com
> www.msnbc.com
> www.wirednews.com
> www.cnet.com

Whether covering entertainment, technology, or politics, Web sites often give priority to the timeliness of information as opposed to cohesive interfaces.

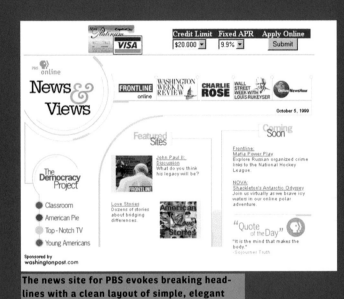

The news site for PBS evokes breaking head-lines with a clean layout of simple, elegant graphics and white space.

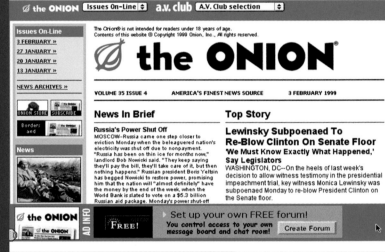

A printed publication that hit its stride on the Web, *The Onion* parodies the content of news as well as its presentation.

> www.pbs.org
> www.theonion.com
> www.chicagotribune.com

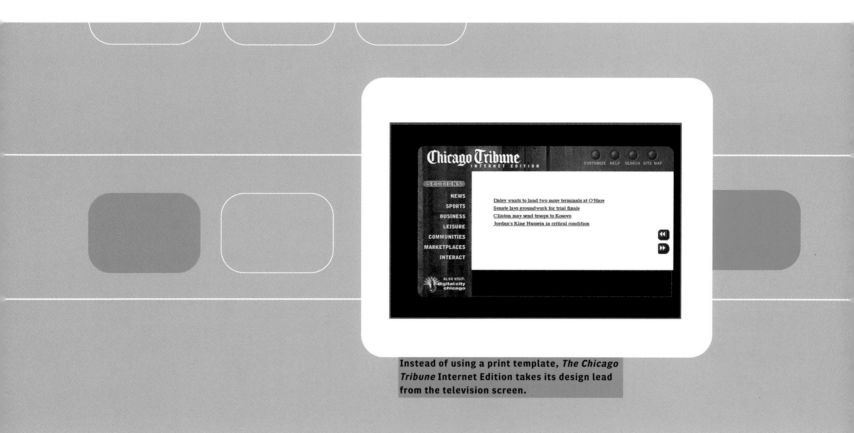

Instead of using a print template, *The Chicago Tribune* Internet Edition takes its design lead from the television screen.

TV and THE
WEB
Then again, on the Internet nobody knows you're a newspaper. Or so thought *The Chicago Tribune* when it redesigned its Internet Edition in 1997. The televisionlike interface features rounded corners, beveled buttons, and fewer elements per screen. Most interestingly, the esthetic of the site is based on a faux TV screen that appears on your actual computer screen, the dimensional illusion completed by a soft drop shadow. But for those visitors who don't like the TV metaphor (and given the feedback, there appears to have been many who didn't like it), there is the option of accessing the site through its original design. This may not be quite what the pundits had in mind when they envisioned the customization of the Web. But why not choose your own design experience? Why leave it to the arbitrariness of browser incompatibility? The television metaphor does work for some sites, especially given the similarities of displaying audio and visual data broadcast from other channels. PostTool's PostTV site not only looks like a TV, with its vertical blue stripes and rounded corner TV screens, but is actually a mock interpretation of the future of Internet entertainment.

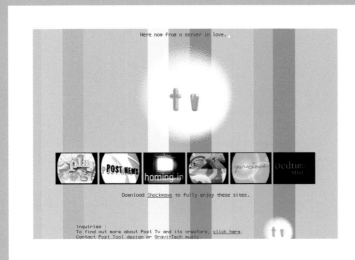

Here now from a server in love.

t v

play POST NEWS homing in [icon] [icon] bedtime star

Download Shockwave to fully enjoy these sites.

Inquiries :
To find out more about Post Tv and its creators, click here.
Contact Post Tool design or Gravi-Tech music.

t v

**Commenting on the future of entertainment,
PostTV reevaluates the TV metaphor with
experimental sound, graphics, and animations.**

Cyber
SPEAK
Slowly, an indigenous design language for the Web has evolved, one that doesn't refer to the conventions of other media. This is the third generation of Web design where the technology is invisible behind the interface, and the metaphors have disappeared beneath intuitive navigation and seamless design. Buttons, boxes, and links are less obvious. Demanding time and providing entertainment, these sites are to be experienced instead of searched. Rollovers hint at clickable content. Rather than a static page, dynamic elements move across the screen, vying for attention. Rather than traversing the hundreds of pages that make up a site, the information flows to the viewer. For example, Volumeone is a site so carefully crafted that even waiting for the studio's signature horizontal color stripes to load is esthetically pleasing. The quarterly experiment combines small films, moving type, and conceptual animations in a presentation that could only be developed on the Web. More simply, *Colors* is a thoroughly Web-based experience that retains the ironic point of view and stark image/word combinations of its print publication. Instead of a comprehensive table of contents, the main *Colors* screen is a backdrop for an animated graphic idea, with a row of issue numbers employed for nav-

Here now from a server in love

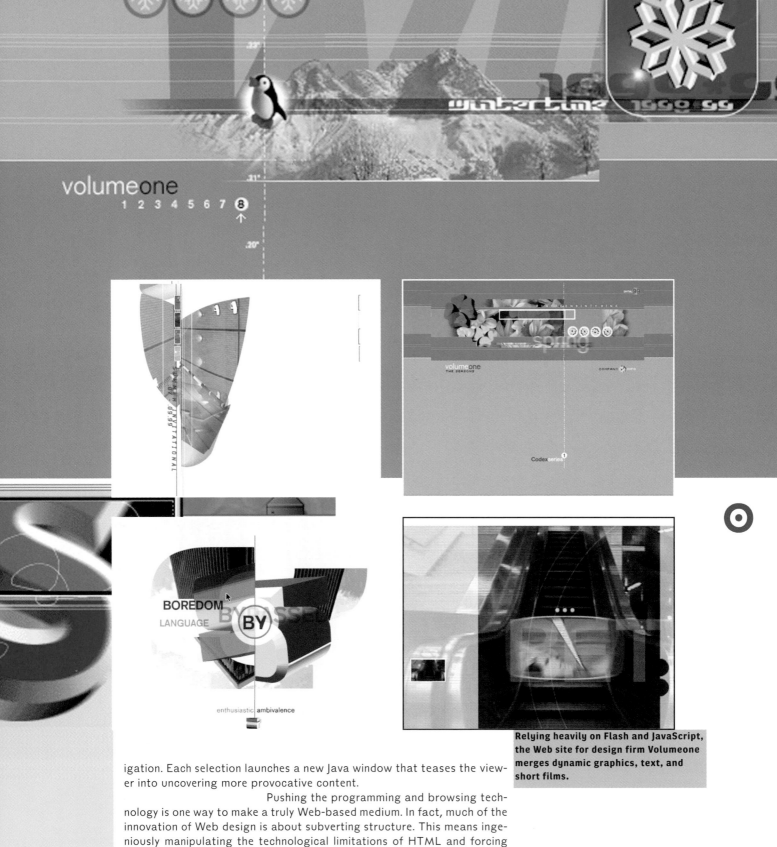

volumeone

1 2 3 4 5 6 7 (8)

Relying heavily on Flash and JavaScript, the Web site for design firm Volumeone merges dynamic graphics, text, and short films.

igation. Each selection launches a new Java window that teases the viewer into uncovering more provocative content.

Pushing the programming and browsing technology is one way to make a truly Web-based medium. In fact, much of the innovation of Web design is about subverting structure. This means ingeniously manipulating the technological limitations of HTML and forcing the browser to do things for which it was never intended. The military could have never imagined Mediaboy. Should you launch this site, a dozen browsers overtake your screen. Mediaboy is hyperactive rather than interactive. A mantra of renegade media philosophies flashes by urging users, for example, to "Kill your television." And it doesn't stop. Only slightly less

> www.volumeone.com
> www.madxs.com
> www.benetton.com/colors/

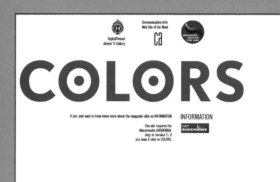

Colors online retains the graphic image-word contrasts of the printed magazine, but the visuals take on a new poignancy in real-time.

dizzying, though equally commanding in hijacking the screen, is Madxs. The site for MAD design studio combines screen saver, tickertape portfolio, and digital commentary into one instantly loading plug-in-less Webcast. It's highly interactive, closely monitored entertainment media.

going MAINSTREAM In the last few years the Web has become its own metaphor. Rather than being replicated on the Web, more traditional media are replicating ideas from the Web. Print and television are adopting aspects of the Web's new visual language to boost their own currency. Magazines are applying a visible hierarchical organization to guide readers through their page-after-page architecture. The design of *Business 2.0*, launched in 1998, includes a printed navigation bar highlighting the section you're in, as well as the preceding and following sections, because, as the editor's note explains, "finding your way around magazines is notoriously difficult." The stories in *Business 2.0* contain underlined text that corresponds to a Weblink noted in the margin by a bitmapped hand cursor. The use of hyperlinks to the Web, known as "footnotes" in the predigital era, can be found even in nontechnocentric mainstream magazines like *Mademoiselle*. The mlle.links that appear on almost every page were the distinction of *Mademoiselle*'s 1999 redesign, which also includes more aggressive Weblike elements: charts, icons, rounded corners, and even that old gray beveled computer window. (Not too surprisingly, the pretty-in-pastel mlle site looks more at home in its corporate Condé Nast site than it does with the modern sassy, made-for-Web grrl sites like Chickclick, RiotGrrl, or Maxi.)

mlle.fix
Q&A FRIENDS by Judith

Q: I live with my best friend, and her boyfriend practically lives with us. Recently, she told me that when they were having sex, he said my name, not hers! Is this my problem or theirs? —P.F., 27

It's uncomfortable enough to realize your lover is mentally boinking the entire cast of *Baywatch*—much less having it off in his head with the girl next door. And if the g.n.d. is also a best friend—yikes! "There could be a number of reasons he yelled his girlfriend's friend's name," notes psychologist Bernie Zilbergeld, Ph.D., author of *The New Male Sexuality* (Bantam, 1984). "Maybe he has the hots for her—or maybe it was a fluke. Or he was angry at his girlfriend, and thinking about

this, when in reality, what's going on is between her and her boyfriend."
 That's assuming, of course, that you haven't fueled any sparks. Beyond general warmth, any flirting with her guy? If you have a clear conscience, this is Not Your Problem—but it's still your concern. All you can do now is be a great friend and show that you deserve the trust your girlfriend puts in you. For the next few months, you should probably quit being the third wheel when they're

Q: My friend takes at least three days to Other friends also seem to feel they c two to five days to return a call to me. something, or is this just life in the '90 Hmm. I don't think that sounds like life in the people are so terrified they'll miss an opportu

Mademoiselle **magazine drives traffic to its Web site with "mlle.links," part of the publication's 1999 redesign.**

www.webex.com

that reaction," adm chuckling Subrah Iyar, chairman and CEO of ActiveTouch. "After Microsoft released NetMeeting, there wasn't much development in real-time online collaboration. That's both a blessing and a curse."
 A blessing, obviously, in that no one's really been bring-

Business 2.0 **magazine lists Web addresses throughout its stories, showing readers where to go for additional information.**

VIDEO, tv, and BEYOND

Elements of Web culture have also turned up on television, the original channel surfer's paradise. First they appeared in VH-1's "Pop-up Video," where factoids about the band, updates, and gossipy tidbits appeared as help balloons superimposed on the video. Today, even video can be recycled, refreshed, and rerun. Fifteen years of fast-paced visual complexity may have made MTV-style a style, but MTV's graphics have become increasingly Weblike. The show "MTV's Buzzworthiest" has a horizontal bar at the bottom of the screen that contains information on how the video became a cultural artifact. The attention-getting (okay, annoying) ad-bannerlike button is a signal to those with remote in hand that what they are looking at is new content. More recently, shows like "Real World Live Chat" use interactivity to bring a strange time-warp quality to a show about real people living together for the purpose of being videotaped. While the show airs, live chat streams across the bottom of the screen. The moderated comments include the revelations of one of the cast members who describes, with all of hindsight's insight, his or her true feelings during the taping of the scene. And the television advertising designscape is littered with click-me, look-at-me graphic devices that mimic Web experience, from program listings with rollover highlights to dramatized click-and-launch windows into a world of desirable products.

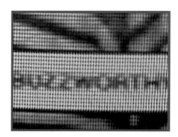
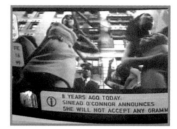

The idea of self-referential information that so defines the Web has been assimilated by older media like television. Clips from "MTV's Buzzworthiest" demonstrate several layers of visual and verbal information on one screen.

The Web could well have materialized into a metaphor for how we currently experience the world. We simultaneously process multiple channels of information, and in fact, we demand more than one source of input to remain stimulated. We feed on simultaneous distractions. We've become a nonlinear culture, more interested in the details, the asides and the links, than the main story itself. We communicate by divergence and diversion. The media of the moment has become the metaphor of our time.

above the fold A term taken from newspaper publishing, referring to the part of a page readers see first. On the Web, it refers to the area of a page users see without scrolling. Like newspaper editors, Web publishers and advertisers try to get important *content* above the fold.

access points Headlines, graphics, and other large, colorful elements on a page designed to catch the reader's eye. See also *reading*.

animated GIF A *GIF* graphic that has multiple layers, which can be played in succession to create animation. The first type of animation widely used on the Web, animated GIFs were the first clue that what appeared on the Web wasn't like print. It excited Web users inordinately, and in 1995, the surest way to sell a Web site design was to include an animated GIF on the home page. Today, animated GIFs are mostly used in ads, where designers use them to annoy to get a little attention.

bitmap A graphic format that creates an image by mapping a series of dots, using copious file sizes to do so. The basic graphic formats of the Web, GIF and JPEG, are bitmap formats. The Web world dreams of the day of *vector graphics*.

branching diagram A chart that imperfectly describes the relationship of the pages of a particular site. Usually, it displays a hierarchical representation that completely ignores the more complex associative links that often tie pages together. This relationship between pages is one that, as far as we know, has yet to be charted successfully.

breadcrumbing A method of showing the path a Web user has traversed in reaching the current page. It's named, one assumes, for the method Hansel and Gretel used to mark their own path through the woods from their home. (It didn't lead them where they wanted to go, either.)

browser wars A race for browser market share between Netscape and Microsoft, 1995–1998. Microsoft pretty much won the war when it started distributing its browser with Windows, but by that time the battle had moved on. Today the two companies do battle with their *portals*.

cascading style sheets (CSS) The flavor of *style sheets* supported by Netscape's and Microsoft's browsers – sort of. Unfortunately, the take-no-prisoners protocol of the *browser wars* meant that Microsoft and Netscape would rush to support for CSS, hack at them for awhile, then follow the race to other fields, leaving CSS supported so spottily and inconsistently they're pretty much unusable. True to the protocol of the browser wars, both companies claim the problem will be solved in their browsers' next versions.

channel A term that formerly referred specifically to *push* content. Since push is no longer recognized, it usually means any content on a Web site that is updated regularly.

chrome The interface elements of a Web browser that surround a Web page, taking up valuable screen real estate. Browser users can control the amount of chrome with their preferences settings. A typical usage might be, "With full chrome, an ad and this *nav bar*, we've only got about 40 pixels to work with *above the fold*."

clickthrough A Web designer's goal, clickthrough is achieved when a Web user actually takes the trouble to follow a hyperlink. Sometimes, clickthrough is used to measure an online advertisement's effectiveness.

client: 1. The person making your life hell. 2. The part of a network program that resides on the user's computer. A Web browser or email reading software, which depends on the other half of the team, the *server*, to feed it information for display. 3. The computer that runs the client software.

content Anything that fills a browser window. Text, graphics, video – anything that can be shoveled onto the server and offered up to Web users.

>

CHATTING THE CHAT:

"GRACEFUL DEGRADATION" AND OTHER CONCEPTS PECULIAR TO WEB DESIGN

TEXT: DARCY DINUCCI

Sure, you've got to master some basic HTML, learn how to think in hypertext structures, and decide whether to nod or to protest when discussing page-building with programmers, but possibly the most time-consuming part of Web design is keeping up with the lingo. In a world where the next big thing might last three months tops, and job descriptions change as often as the **ABC** comedy lineup, **talking the talk is one way to make sure everyone knows you know the latest Web buzz.** Here is a handy guide to Web-building's current vocabulary—a mixture of terms that are here to stay and others that will shortly be toast. One caveat to keep in mind: being a Web designer means being au courant, not just with Indian cigarettes, nylon clothing, and hip nightspots, but with Web speak as well. This list will get you started, but keep your ear to the ground. **"Out-of-it Web designer"** is an **oxymoron.**

access points

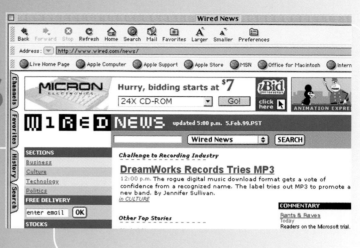

branching dia

above the fold A term taken from newspaper publishing, referring to the part of a page readers see first. On the Web it refers to the area of a page users see without scrolling. Like newspaper editors, Web publishers and advertisers like to get important *content* above the fold.

access points Headlines, graphics, and other large, colorful elements of a Web page designed to catch the reader's eye.
See *reading*.

animated GIF A *GIF* graphic that has multiple layers which can be played back in succession to create animation. The first type of animation widely used on the Web, animated GIFs were the first clue that what appeared on the screen wasn't like print. It excited Web users inordinately, and in 1995, the surest way to sell a Web-site design was to include an animated GIF on the home page. Today, animated GIFs are mostly used in ads where designers are willing to annoy to get a little attention.

bitmap A graphic format that creates an image by mapping a series of discrete dots using copious file sizes to do so. The basic graphic formats of the Web, GIF and JPEG are bitmap formats. The Web world dreams of the next wave, vector graphics. See *Flash*.

branching diagram A chart that imperfectly describes the relationship between the pages of a particular site. Usually, it displays a hierarchical structure, a representation that completely ignores the more complex associations of hyperlinks that often tie pages together. This relationship between hyperlinks is one that, as far as we know, has yet to be charted successfully.

> www.shift.jp.org
> www.wired.com/news/

breadcrumbing
browser wars
cascading style sheets

breadcrumbing A method of showing the path a Web user has traversed in reaching the current page. It's named, one assumes, for the method Hansel and Gretel employed to mark their own path through the woods from their house. (It didn't get them where they wanted to go, either.)

browser wars A race for browser market share between Netscape and Microsoft, 1995–1998. Microsoft pretty much won the war when it started distributing free browsers with Windows, but by that time the battle had moved elsewhere. Now the two companies do battle with their portals.

cascading style sheets (CSS) The flavor of style sheets supported by Netscape's and Microsoft's browsers—sort of. Unfortunately, the take-no-prisoners approach of the browser wars meant that Microsoft and Netscape would both declare support for CSS, hack at them for awhile, then follow the race to other, hotter battlefields, leaving CSS supported so spottily and inconsistently that it's pretty much unusable. True to the protocol of the browser wars, both companies have declared the problem will be solved in the next versions of their browsers.

channel A noun that formerly referred specifically to *push* content, but now that push is no longer recognized, it usually means any content on a specific subject that is updated regularly.

chrome The interface elements of a Web browser that surround a Web page, taking up valuable screen real estate. Browser users can control the amount of chrome with their preferences settings. A typical usage might be something like, "With full chrome, an ad and this *nav bar,* we've only got about 40 pixels to work with *above the fold*."

clickthrough A Web designer's goal, clickthrough is achieved when a Web user actually takes the trouble to follow a hyperlink. Sometimes, clickthrough is used to measure an online advertisement's effectiveness.

client 1. The person making your life hell. 2. The part of a network program that resides on the user's computer. A Web browser or email reader is client software, which depends on the other half of the team, the *server,* to feed it information for display. 3. The computer that runs the client software.

content Anything that fills a browser window. Text, graphics, video—anything that can be shoveled onto the server and offered up to Web users.

content creator The person designated to manufacture *content.*

channel

chrome

clickthrou

client

content

content cr

document object model

times

arial

helvetica

do you want to get medieval **?Trebuchet**
on your desktop and Web browser | a free TrueType typeface

do you know another typeface **?Verdana**
that's this legible on screen at small sizes | download it for free!

tired of Times New Roman **?Georgia**
Microsoft presents a new serif type family | it's free!

document object model (DOM) A model for naming all the different parts of a Web page which Web authors use to control the behavior of those parts with *JavaScript*. The fact that Microsoft and Netscape used different DOMs in their 4.0 browsers made it necessary for anyone using *dynamic HTML* to write different versions of JavaScript code for each browser.

downloadable fonts The most anticlimactic answer to a designer's dreams in Web history (so far). The idea was to let Web designers use any font they wanted for HTML text, not just the fonts native to both Macintosh and Windows systems—Times and Arial or Helvetica. As the name suggests, the technique entails actually sending the font along with the HTML file. The browser makers devised ways to placate font designers with technologies that made sure people couldn't use the downloaded fonts for other documents, but there still remained two problems. Font files are big (even in the compressed, downloadable formats), and thanks to the *browser wars,* there are two competing standards for downloadable fonts: TrueDoc (from BitStream and Netscape) and OpenType (from Microsoft and Adobe). The upshot: no one uses them.

downloadable fonts

dynamic An all-purpose adjective used to describe Web pages to clients. Among its meanings are 1) exciting, 2) animated, 3) better than the last version, and 4) created on the fly from a database so that it changes from one viewing to another.

dynamic HTML *HTML* that is, well, *dynamic.* It is better than the last version: you can use it to place page elements at precise positions on the page and use *JavaScript,* if you want, to move the elements around the screen.

e-commerce The reason, which became clear sometime in 1998, that it might actually make good business sense to put up a Web site.

Flash A program from Macromedia that lets you create animated vector graphics. The effects are great, but you can't really use the technology for any important content because users have to have a *plug-in* to see the Flash content.

form-giver A term *information architects* use to refer to *graphic designers.*

graceful degradation The behavior of a well-coded page in older browsers. A page is said to degrade gracefully if it looks okay and works acceptably in browser versions that don't support the latest *HTML* and *JavaScript* code—even if it doesn't have all the bells and whistles it would have in browsers that do.

graphic designer The person charged with making a Web page look good. See *form-giver.*

dynamic

dynamic HTML

e-commerce

flash

form-giver

ul degradation

raphic designer

bits
html
html 2.0
html 3.0
html 3.2
html 4.0

hits The number of times a user requests a file from a Web server. Web publishers want as many hits as possible, because the more hits, the higher the rates they can charge for ads on the site. Hits are a famously inexact measure of actual site usage, though, since the number of hits a single page generates depends on how the page is created; a page with six graphics, for instance, would create seven hits each time it's called, while a page without graphics would create just one.

HTML (HyperText Markup Language) Based on *SGML* and created by Tim Berners-Lee as a proof of concept when he invented the World Wide Web. HTML was never, never, meant to describe page layout, hence all our problems.

HTML 2.0 The version of *HTML* first documented by the *W3C*. It essentially consists of Tim Berners-Lee's original HTML tags plus a few more for online forms.

HTML 3.0 Originally slated to be the next official version of *HTML* after *HTML 2.0,* it never actually materialized. One effect of the *browser wars* was the ad hoc creation of new HTML tags by the browser makers, who supported their own, design-oriented tags to get Web-site creators to design specifically for their browsers. By the time HTML 3.0 made it through the *W3C* committees and came up for ratification, it was completely beside the point—it had nothing to do with the HTML actually being used.

HTML 3.2 The actual official version of *HTML* following *HTML 2.0*, it marked a truce of sorts between browser makers and the *W3C*. Essentially, the W3C caved in and recognized most of the maverick tags supported in the browsers and already in wide use on Web pages.

HTML 4.0 The third official version of HTML, incorporating *cascading style sheets* and *dynamic HTML*.

```
<LINK rel="alternate stylesheet" title="compact" href="small-base.css" type="text/css"
<LINK rel="alternate stylesheet" title="compact" href="small-extras.css" type="text/cs
<LINK rel="alternate stylesheet" title="big print" href="bigprint.css" type="text/cs
<LINK rel="stylesheet" href="common.css" type="text/css">

<LINK rel="alternate stylesheet" title="compact" href="small-base.css" type="text/css"
<LINK rel="alternate stylesheet" title="compact" href="small-extras.css" type="text/cs
<LINK rel="alternate stylesheet" title="big print" href="bigprint.css" type="text/css"
<LINK rel="stylesheet" href="common.css" type="text/css">
```

bits

html

html 2.0

html 3.2

html 4.0

hyperlinks

hypertext The whole idea behind the Web. In a hypertext system, users can choose their own paths through the material, theoretically following their own thought patterns rather than an author's.

Internet appliance A device created for a special purpose that uses the Internet—think dashboard restaurant finder, not personal computer. When Internet appliances become more common, the idea that you might be able to create one set of code that will work for all client software (the idea behind *SGML* and thus, the Web) will be put to rest once and for all.

information designer 1. Any designer who creates designs crafted to help a reader understand the designed content. 2. A designer specializing in the design of material—signage systems, IRS forms, infographics, and the like—where information, not identity, is the primary brief. 3. (archaic) A designer whose job is to create the information hierarchy and navigation system for a Web site. (Now largely replaced by *information architect* or *interaction designer*.)

information architect The person in charge of devising a structure for a Web site. See also *information designer, interaction designer*.

interaction designer The person in charge of designing a path through a Web site or other interactive environment and devising any feedback the user receives during the interaction.

internet
java
java virtual
machine
javascript
markup language

Internet The network over which services such as the Web are carried. It is *not* the same thing as the Web, but it might as well be.

Java A cross-platform programming language, a.k.a. the Next Big Thing on the Web c. 1995, 1996, 1997, 1998, and 1999. Most programs need different versions for each type of processor, but Java programs can run on any computer that has a *Java Virtual Machine*. That makes it a natural for the Internet, where all types of computers are demanding info from Web *servers*. Java still seems like a good idea, but like almost every other Web technology, is taking a lot longer to mature than most people at first figured.

Java Virtual Machine A piece of software that sits on the *client* machine, designed to interpret *Java* programs. The one on the Mac has, historically, been substandard, making Java programs really useful only for Windows machines despite all the cross-platform hopes.

JavaScript A scripting language for Web pages, designed to facilitate interaction on the client end of a Web connection. Called JavaScript in order to borrow reflected glory from *Java*, which at the time of JavaScript's invention, was all anyone on the Web cared about. In reality, JavaScript has nothing to do with Java.

markup language A set of codes embedded in a text file that instructs a piece of software, such as a browser, how to display the file. The mother of markup languages is *SGML*, from which were born *HTML, XML, VRML,* and tons of other MLs designed for different types of information.

This page contains information of type "application/x-shockwave-flash" that can only be viewed with the appropriate plug-in. What do you want to do?

Plug-in Info Cancel

persona

< >
< >

< >

< >
< >
< >

<

meta information Information about information. On the Web, this usually refers to terms used in an HTML file's <META> tag, which provide descriptors of the kind of content to be found in the file (e.g., "sex, nude, XXX"). Using the <META> tag this way helps search engines find relevant information in response to keyword searches.

navigation bar A standard navigation tool for Web pages: a row of hyperlinks to the site's main sections that usually ranges across the top of a Web page. Often shortened in speech to "nav bar."

PDF (Portable Document Format) A file type devised by Adobe for the sharing of electronic documents before the Web was invented. Now used as an alternate format for displaying documents on the Web for those who don't have the time or budget to translate those pages into *HTML*. PDF files require Adobe's Acrobat reader to be viewed. See *repurposing*; cf. *standards*.

PERL A scripting language often used to automate actions on Web *servers*.

personalization One way Web publishers think they can create *stickiness.* The idea is that if users can customize a site's *content* to show information they're especially interested in, they will have an investment in that site, and will return there again and again.

plug-in A software module that adds functionality to a browser. In most cases, plug-ins add the ability to play a certain file type (something other than *HTML*, *GIF*, or *JPEG*) in the browser window. See e.g., *Flash*.

portal Besides e-commerce, the only other way to make money on the Web. A portal is a gateway to the Web, a site that offers a catalog of other content and (usually) a Web search engine for finding more. By being a site people return to when beginning to launch their forays onto the Web, a portal can get lots of *hits,* and therefore charge a lot for ads.

programmer Web designer. When it gets right down to it, what you can do on a Web page depends on what the programmer you're working with will allow you to do.

push (archaic) The theory was that instead of making Web users come to you, you could send your Web page to them—with new content delivered with the convenience and regularity of the morning newspaper. It never really worked, though; it seems that people liked to use the Web to "pull" information—to search it out when they need it.

reading What people don't do on the Web. Tests have shown that the first thing anyone does when a new Web page loads is to look for somewhere to click—namely, graphics or blue, underlined text. Any text they see there is just texture. If they find information they're looking for, they'll print it out.

recirculation The cycling of Web users inside the borders of a Web site. In a world in which advertising revenue is set by the number of *hits* on a site, publishers aim to keep users clicking inside the boundaries of their own Web site as long as possible, cf., *hypertext.*

repurposing The idea was that content already on hand from books, magazines, brochures, and other old-style publications can be reused on the Web. It doesn't work. See *shovelware.*

recirculation

repurposing

rollovers An action that occurs when users roll their mouse over an on-screen graphic—usually a pop-up message giving information about the object rolled over. Rollovers are the second Web-design innovation that actually proved useful and caught on, often employed with the first, a *navigation bar*.

SGML (Standard Generalized Markup Language) Created as a way to make sure that important documents would not be made useless by obsolete technology and could be reused for different purposes. SGML documents are pure text (so they aren't dependent on any particular software) but their structural elements are identified by "tags," codes in angle brackets. Using SGML-aware software, you could then apply style sheets to them to display them in any number of ways. Different publishers can create different types of tags to describe their documents. When Tim Berners-Lee created the Web, he devised a set of SGML tags he called *HTML* to provide a format for simple documents and a method of creating hyperlinks between them.

rollovers

sgml

```
<!DOCTYPE HTML PUBLIC "-//W3C /DT      M      N"
       "http://www.w3.org/TR/REC-html40/strict.dtd">
<HTML>
   <HEAD>
      <TITLE>My first HTML document</TITLE>
   </HEAD>
   <BODY>
      <P>Hello world!
   </BODY>
</HTML>
```

shovelware Web content *repurposed* from other media with no thought given to the form it requires in its new home. See *PDF*.

standards The religion of Web developers. The forces of good ranged against the forces of evil, companies that try to own key technologies on which the Web depends. As long as the Web is based on standards, such as *HTML*, in the public domain and watched over by the *W3C*, the Web can't be hijacked by vendors hoping to force people to buy certain technology in order to use it.

stickiness The ineffable quality of a Web site that keeps readers hanging around *recirculating* through the site and delivering those elusive *hits* that Web publishers depend on.

style sheets On the Web, as in a page layout or word processing program, a set of styles defined for different elements of a document. Using style sheets lets you define and change styles globally. See *cascading style sheets*.

VRML (Virtual Reality Modeling Language) A markup language for creating 3-D interfaces for Web sites. Since the dawn of the Web, a band of die-hard believers has been working to develop the language and VRML-compliant browsers. After all, the world is 3D, so why shouldn't the Web be? For some reason, it has never caught on.

shovelware

standards

stickiness

Web design An amalgam of *information architecture*, *interaction design*, interface design, *graphic design, HTML* engineering, and *programming,* which come together—with various degrees of success—to create an experience for a visitor to a Web site.

world wide web consortium (W3C) A nonprofit consortium of academics and software vendors that come together to hammer out *standards* for the Web.

writer See *content creator.*

XML (Extended Markup Language) A revision of *SGML* created especially for the Web. Like SGML, it allows publishers to create their own sets of tags to define their documents, but its rules are somewhat more lax than the rules of XML, making it more likely to be widely. Netscape and Microsoft say that XML will be supported in the 5.0 versions of Netscape's and Microsoft's browsers. Stay tuned.

style sheets

vrml

web design

world wide web consortium

writer

xml

times
helvetica
verdana
arial
georgia
courier
trebuchet
comic sans

TYPE ON THE
WEB:

g g g

THE PRINCIPLES OF MACRO- AND MICROTYPOGRAPHY

TEXT: CLIVE BRUTON

Take a look at type, onscreen, in your browser. What you see is similar to what about 10 percent of the people looking at the same page with different browsers and different operating systems will see. The remaining 90 percent will see something markedly different. Keeping this in mind, how is it possible to treat type consistently on the Web? What exactly is type on the Web? And how can it be made better?

Fundamentally, the answers to these questions are bound up in the technologies that both make and deliver HyperText Markup Language (HTML), technologies that weren't designed with high-end typography in mind. HTML was developed to deliver information as pure text—graphics and style were afterthoughts. The main concern of the creators of HTML was that documents be readable on as wide a variety of hosts as possi-

one 2 one

services phones coverage costs shopping information

the range
all - in - one
up 2 you
accessories
considerations
EFR

select an option below ▼

→ one 2 one anytime
→ one 2 one anytime 60
→ one 2 one anytime 1200
→ precept

contact
about us

What it costs - time plans

↩ back

All prices include VAT at the current rate of 17.5%

Time plan charges	one 2 anytime	one 2 anytime 60	one 2 anytime 1200	precept 100	precept 300	precept 600
Service provision and smartcard (once only charge paid in store)	£35	£35	£35	£35	£35	£35
Monthly service charge with direct debit	£15	£18	£25	£25	£35	£50
Extra monthly charge with any other payment method	£1	£1	£1	£1	£1	£1
Free calls/month	None	60 minutes free Usetime (local/national/other One 2 One customers)	1200 minutes free Extratime (evenings and weekends, local and national calls only)	100 mins free Usetime (local/national/other One 2 One customers)	300 mins free Usetime (local/national/other One 2 One customers)	600 mins free Usetime (local/national/other One 2 One customers)
Rollover	N/A	YES	NO	YES	YES	YES
Call charges in pence for a one minute direct dial voice, fax or data call						
Daytime						
Local & National calls	10	10	10	5	5	5
Calls to other One 2 One customers	20	20	20	10	10	10
Calls to other mobile operats' customers	40	40	40	20	20	20
Evening/Weekend						
Local & National calls	2	2	2	5	5	5
Calls to other One 2 One customers	10	10	10	10	10	10
Calls to other mobile operators' customers	20	20	20	20	20	20
Voicemail message retrieval	FREE	FREE	FREE	FREE	FREE	FREE
Service options						
Text messaging/month (or part month)	£1	£1	£1	FREE	FREE	FREE
Mobile e-mail Service/month (or part	£1	£1	£1	£1	£1	£1

The original design for the One2One cable and wireless Web site employed a table seemingly taken from a print source and rasterized as a GIF (above).

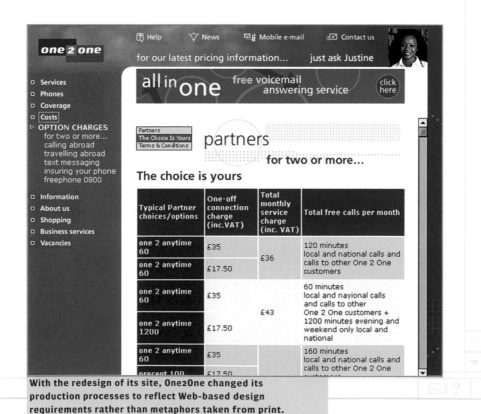

? Help ○ News ✉ Mobile e-mail Contact us

one 2 one

for our latest pricing information... just ask Justine

all in one free voicemail answering service click here

□ Services
□ Phones
□ Coverage
□ Costs
▷ OPTION CHARGES
 for two or more...
 calling abroad
 travelling abroad
 text messaging
 insuring your phone
 freephone 0800
□ Information
□ About us
□ Shopping
□ Business services
□ Vacancies

Partners
The Choice Is Yours
Terms & Conditions

partners
for two or more...

The choice is yours

Typical Partner choices/options	One-off connection charge (inc.VAT)	Total monthly service charge (inc. VAT)	Total free calls per month
one 2 anytime 60	£35	£36	120 minutes local and national calls and calls to other One 2 One customers
one 2 anytime 60	£17.50		
one 2 anytime 60	£35	£43	60 minutes local and nayional calls and calls to other One 2 One customers + 1200 minutes evening and weekend only local and national
one 2 anytime 1200	£17.50		
one 2 anytime 60	£35		160 minutes local and national calls and calls to other One 2 One
precept 100	£17.50		

With the redesign of its site, One2One changed its production processes to reflect Web-based design requirements rather than metaphors taken from print. The result is a sleeker, smarter use of text.

> www.one2one.co.uk

ble. The flexibility and availability of information, not its presentation, were paramount. We also have to remember that print, our main point of reference for typography, has been around for about 500 years, evolving continuously over that time. Although it will undoubtedly continue to evolve, in comparison to the Web, it is a vastly more mature medium with established tools and workflow patterns. We have entire libraries through which to track the development of the medium, and to learn from past mistakes. The Web, on the other hand, is brand new. All the learning and all the mistakes are happening right here, right now, on a Web site near you.

THE PRINT PARADIGM

In discussing typography on the Web, it's important to consider the difference between type off-screen and type onscreen. One is essentially fixed: Once it's printed, it's history. The other is constantly in flux, updated regularly. There's nothing worse than finding a static Web site that looks years out of date. With print, designers know exactly how something will be seen and used—give or take a few variables like lighting and aging of the product. On the Web, designers have next to no idea. This requirement imposes a more open attitude toward deliverable visual structure, dictated by flexibility and, of course, the data itself.

I asked a few digital typographers what they thought were the differences between typography for print and for the Web. About the most succinct answer I received was from David Berlow at Font Bureau: "You have control of print and no control of the Web. In fact, there is no typography on the Web at all. There is only type." It was this comment of Berlow's that led me to realize that perhaps we need to view typography in two ways: as an art practiced only in print, and as the description of assembled written matter.

MICRO- and MACRO-

That said, where is the dividing line between what is and what isn't considered typography? In order to address this issue, I will raise two ideas: micro- and macrotypography. As designers and typographers, we probably most often work with microtypography—kerning, spacing, alignment, and the subtleties of type design. In designing for the Web, we must learn to be equally adept with macrotypography, giving structure and uniformity to amorphous content. In this discussion, the term structure arises quite often. Structure is at the core of macrotypography. Any HTML evangelist will tell you that structure is also the heart of any markup language. In design for print, structure is visual structure, what we see on a page when output or printed. Design for the Web does include this notion, but it also involves other structural concerns, such as HTML coding, workflow, and flexibility in a dynamic media. If you can put all these components together, you're in a win-win situation. Separate them and you can only lose.

Micro- and macrotypography aren't really new concepts. Print typography involves both, although the macroaspect is generally overlooked because of the detailed microtypography. As designers, we shed tears over the subtle

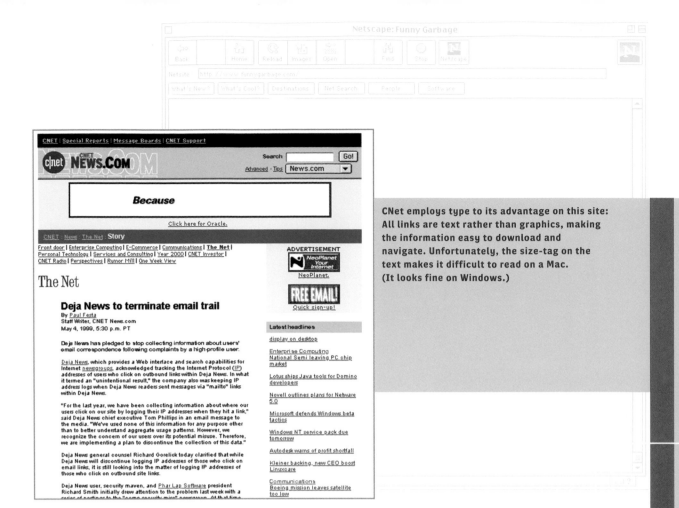

stuff, and trust house style or a grid to look after macrodecisions. Just pick up a magazine and flip through it. The type style is relatively the same all the way through. Even if the text face changes several times while skimming the pages, at this zoomed-out macrolevel it is still possible to identify several aspects of style that unify the publication. What we see are the bare bones of structure: color usage, column widths, and head and subhead distinctions. Such things are independent of content and independent of all the microaspects we're used to laboring over.

THINK BIG

Macrotypography is the true driving force behind type style on the Web, and will remain so for some time to come. From the perspective of actually producing content for large Web sites, the tools and technology now exist for light-touch macrotypography. Implementing wide-ranging changes to core elements can be very simple across huge numbers of individual files. The opposite is true of microtypography, which necessarily involves a mass of individual decisions that cannot easily be applied across entire sites. Again, we are addressing the relative maturity of the two media, print and the Web. One has a proven tool set to deal with its evolved needs. The other has problems of perception from every corner: consumer, designer, and toolmaker/application vendor.

Macrotypography exists in the form of a cohesive overall typographic structure; microtypography, on the other hand, doesn't necessarily enhance, and may even harm, page viewing and functionality. Moreover, the sites that deal with these issues appropriately have probably hired consultants to work with these facets. Most likely, the sites that deal with typography successfully will be linked to publications whose daily existence relies on low-level style, such as newspapers and weekly magazines.

INVISIBLE typography

So whatever happened to microtypography for the Web? Vince Connare of Microsoft sums up the answer in one word: "Resolution." Today, high-resolution processing is available in a print industry that was fundamentally analog 25 years ago. This is an era of 1200dpi laser printers, 2400dpi image setters, and 150lpi screens for color print. In the midst of all these high-resolution digital output devices, our interface with the digital world is decidedly low resolution—the cathode-ray tube. If you're lucky, you might have a computer display running at 120dpi or so, but most screens run somewhere between 80 and 100dpi. At those average levels of resolution, typical screen type is on an em square of 10 to 14 pixels. At that rate, it's difficult to see the differences between a sans and a serif, let alone identify Garamond from Bodoni, or Univers from Gill. Of course, you can do this if you want to check the typeface pixel by pixel, but you're supposed to be reading!

And there's the rub. Good typography is supposed to be invisible to the reader. To make subtleties apparent, they must be made visible. To do so at such low resolutions will break whatever macrotypographic devices

> www.news.com
> www.macromedia.com
> www.shell.com

macromedia : company info : international : events : eucon 99 : registration informa

macromedia
EUROPE UCON 99
add life to the web
June 24 - 25, 1999
Disneyland Paris
Paris, France

REGISTRATION INFORMATION

Registration now for the June 24– 25 Europe UCON '99. Registrations will be
processed by CTS Ltd., when payment is received.

REGISTER ONLINE NOW ▶

1999 Europe UCON 99 registration fees
Individual registration

- Full conference fee £500.00 €730.00
- Authorized Training Centres (30% discount) £350.00 €510.00
- Authorized Developers (30% discount) £350.00 €510.00
- Education Special (2 day pass) £250.00 €365.00

Group registration
Note: All 4 registrations must be from the same company and must be received
together.

- Buy 3 get 1 free (4 conference passes) £1,500.00 €2,190.00

Conference registrations will be subject to French V.A.T. at the current rate.

PROGRAM
training
at-a-glance

REGISTRATION
register now
pricing
hotel/travel

GALLERY
call for entries

EXHIBITION
opportunities

SPONSORS
sponsors
opportunities

REQUEST INFO
get on the ucon 99
mailing list or ask
a question

buy ○
search ○

[home] [shockwave] [software] [support] [macromedia] [shockrave] [help]
Trademarks Copyright ©1995-1999 Macromedia Inc. All rights reserved. Privacy Policy.
Mirror Sites: [Asia] [Europe] [USA]

Type is generally well-treated in this example
from the Macromedia European User Conference.
A few large graphics are repeated throughout
the site, so time isn't wasted downloading new
images on every page. Unfortunately, the
navigation palette and hierarchy bar to the top
and right side of the page are graphics and
remain the same throughout the site: None of
the graphics dim to show where you have
been or glow to indicate your current position.
The maintenance on graphic navigation bars can
be time-consuming because they must be
replaced every time there is a change in
site organization.

🐚 ROYAL DUTCH/SHELL GROUP OF COMPANIES
email | search & browse | help

Home > Annual Reports 1998 > Royal Dutch Petroleum Company Annual Report 1998

[Group Operational Data ▼] [jump to: ▼]

**Royal Dutch /
Shell Group of Companies**

Group Operational Data > Operational Comparisions 1994–1998 > Crude oil production

Crude oil production

🖥️ Click icon to download this table in Excel format

- **Crude oil production**
- Natural gas sales
- Refinery processing intake
- Oil sales
- Group share of Equilon and Motiva volumes
- Tanker fleets
- Chemicals sales: net proceeds
- Employees

To visit the Parent
Company pages please
use the pull down
menus

(including Group share of associated companies) thousand barrels daily

	1998	1997	1996	1995	1994
Europe	**590**	551	560	533	525
Africa	**377**	423	423	411	398
Middle East	**476**	455	456	472	467
Asia-Pacific	**261**	264	290	264	239
USA and Canada	**589**	559	528	512	482
Other Western Hemisphere	**61**	76	48	62	83
	2,354	2,328	2,305	2,254	2,194

million tonnes a year

	1998	1997	1996	1995	1994
Metric equivalent	**118**	116	115	113	110

The figures shown in the table above, which include natural gas liquids, represent the totals reported by
Group companies together with the Group share of associated companies.

The navigation hierarchy on the
left-hand side of this page for
Shell is text, which changes
color to indicate visited links.
The navigation is topped by the
name of the current section in
boldface. The central table here
is text, not a graphic, and is
easy to read at almost
any size.

Good typography should be invisible, so can you read this? Or are you more concerned with the typeface?

Good typography should be invisible, so can you read this? Or are you more concerned with the typeface?

Good typography should be invisible, so can you read this? Or are you more concerned with the typeface?

Good typography should be invisible, so can you read this? Or are you more concerned with the typeface?

Good typography should be invisible, so can you read this? Or are you more concerned with the typeface?

Good typography should be invisible, so can you read this? Or are you more concerned with the typeface?

Good typography should be invisible, so can you read this? Or are you more concerned with the typeface?

Good typography should be invisible, so can you read this? Or are you more concerned with the typeface?

↑ Given that different typefaces are difficult to distinguish at low resolutions, does specifying or embedding particlar faces add to the design experience? This type at 12ppem (pixels per em) contains hand-edited bitmaps. At this size, it's very difficult to discern the difference between the above fonts (from top to bottom): Univers, Gill Sans, Adobe Garamond, and Bodoni.

↑ At 16ppem, you can just make out the characteristics of each font, but there is little fidelity to their original designs.

are holding the structure of the page together. Type as graphics is most often the culprit, made worse by text size-tags. Type as a graphic is simply not reusable or scalable. You cannot copy and paste such text. You cannot search for it locally in your browser or via a search engine. As an example, if I create a "graphic" sub-head in a section of text, what is its size/weight relationship to the body copy? If you know the answer, then you know more than I do. While the variables of the text display are almost infinite, the graphic can only be seen one way, and therefore it has no relationship to the text. In extremes, it may be many times larger than the body copy, or it may even end up smaller.

LOW-RES FONTS

The other problem with attempting microtypography on the Web is that it is heavily reliant on typeface design. To a large extent, typefaces aren't portable, i.e., they're pieces of software that require a license to use on your local machine or network. You can't distribute these to anyone and everyone who visits your Web site. (In all cases, designers should refer to the End User License Agreement— EULA—that comes with the fonts when purchased.) The only alternative, then, is to go for the lowest common denominator: Times, Helvetica, Arial, Courier, and other faces that are distributed with operating systems. (Windows core fonts are available for MacOS via download from Microsoft.)

To complement this restrictive selection, Microsoft has released a set of fonts heavily developed for screen uses: Verdana and Georgia by Matthew Carter and Trebuchet and Comic Sans by Vince Connare are among this set. Connare has this to say about fonts designed specifically for the screen: "They have a mechanical look resulting from being designed for a low-resolution device. They also lack the subtle humanistic characteristics of the original when onscreen, and some lack a soul." This comes back to the point I made earlier: There is no room for the subtleties of microtypography on the Web. It's somewhere you just can't go. Connare is supportive of a commercial future for low-resolution fonts outside of OS/Web browser giveaways. He indicates, however, that it won't be easy considering that the fonts are "too hard to make." Essentially, a high degree of manual hinting takes place to correct screen display. This is neither quick nor easy, so making low-resolution fonts takes much more work than high-resolution ones. "As they're complicated to make, there will be a tiny market in developing those fonts for OS developers," says Erik van Blokland of Letterror. "Every user will have a copy. It won't make sense to try and sell them." Having tested the boundaries of type on the Web for the last few years in his own work, van Blokland has a keen perspective on why the Web paradigm is so confined to the print metaphor, and why there seems to be no movement in rethinking this traditional approach: "Fonts designed for screen will be used for anything but the screen: Charcoal on a CD cover, Verdana on a barber-

times

helvetica

arial

courier

verdana

georgia

trebuchet

comic sans

The central text on this page from font.org is live,
but a size-tag on the text makes it difficult to read.

shop window. Other than specially hinted fonts, there aren't that many faces available that take advantage of being onscreen. There's nothing that animates, moves, or wriggles." This is the most frustrating aspect of type for the Web: It's relatively difficult to move away from the print paradigm, to deliver content, and to not break the viewer's browser, all at the same time. "Having noncompatible browsers, Java, and JavaScript implementations certainly doesn't help the situation," van Blokland maintains.

BEYOND PRINT If digital designers are so restricted is there any hope for change? If so, when?

Screen resolution isn't going to be modified radically anytime soon. A more likely shift will be from cathode-ray tubes to liquid-crystal displays. Paradoxically, as the latter is a less-developed technology, it's more likely that this shift may actually slow down the widespread adoption of higher-resolution screens. Thus, better microtypography on the Web seems a long way off. In the

> www.font.org
> www.reuters.com
> www.microsoft.com

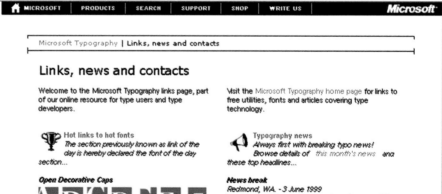

Text navigation can often do the funky things that people usually associate with graphics and JavaScript. One example is this text rollover from the Reuters Web site—when the cursor goes over a link, the text is highlighted and underlined.

Kevin Overland of Canada tucks into a corner as he competes in the first race of the Olympics speed skating men's 500 metres at the M-Wave Stadium. Photo by Blake Sell REUTERS

Reuters today

In 1998 Reuters set out to engineer one of the biggest organisational changes in its 150-year history. We decided to transform ourselves from a horizontal structure managed by areas and country units to become a vertical organisation driven by our main businesses and measured by their profitability.

The growing globalisation and integration of financial markets made the new structure essential to develop global customer relationships, since many of our clients already manage themselves this way.

There will be two main business divisions, Reuters Information and Reuters Trading Systems. They will distribute products through the Global Sales and Operations Group. Our third large business, Instinet, continues to operate as an autonomous subsidiary. The company's Corporate and Media Information business is managed separately.

The structure includes specified functions which run across all businesses, including Strategic Planning and the post of Chief Technical Officer, who takes the lead in establishing a unified and cost-effective technical infrastructure.

REUTERS INFORMATION DIVISION

This Web page for Microsoft Typography is a rare example of a successful multicolumn layout. The two columns are distinct text-threads and aren't directly related.

63

↑ The magenta pixels represent a hinted rasterization, the cyan, an unhinted one.

↑ A font converted from the original PostScript or TrueType, shown in blue, is contrasted with one from the TrueDoc format, shown in red. The TrueDoc font, created by autotracing the original PostScript or TrueType font, is of inferior quality. It also has more control points on its outline, which makes it inefficient to draw onscreen. Additionally, the control points in the original fonts, the "hints," are destroyed in the autotracing process. Thus, TrueDoc will render as an unhinted or autohinted outline and will look poor onscreen, especially at lower resolutions.

meantime, designers will have to deal with clients continually asking for demanding designs for their sites. Some of the common requests I've received during briefing sessions include: "I want it to look just like my corporate style," and "I want the Web version to be identical to the print version." At the same time, designers are also stuck with "print" mind-sets that fail to address the strengths of the Web. We try to impose style on structure, force-feed print metaphors to screen media, and prevent free and flexible interpretation of content. Of course, we have excuses: We're doing what we know, and what our customers want. And the current selection of developmental tools found on our desktops does little to help the situation.

EMBEDDED FONTS

One technology that may work, for display type, is embedded fonts. At least many designers and typographers are attempting to address some of the problems they confront with this technology. "[Embedding] can be something useful," says van Blokland. "But only after layout, content, structure, color, and writing have been taken care of. When these things haven't been done well and carefully, embedding a font is rather pointless. Fixing mistakes in macrotypography can-

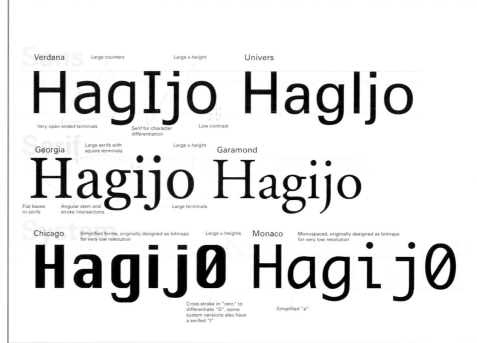

Verdana and Georgia, onscreen fonts by Matthew Carter, are contrasted with the traditional print fonts Univers and Garamond. Chicago and Monaco are original Apple system fonts. The above faces were designed for quite different purposes and you'll often see them used inappropriately: Univers and Garamond may survive the rigors of the screen, but Verdana, Georgia, and Chicago will probably never look good outside of their intended applications. Monaco may be the most flexible of the above faces because of its quirky adaptation to a vector design.

not be done on a microtypographic level. The type might be nice, but the page will still be impossible to read. Besides, incompatible technologies make embedding a bigger effort than the net result will justify." Where can we go from here? Only back to the basics.

A practical guide to keep in mind is that, on the whole, macrotypography is a friend, while microtypography breaks structure and destroys portability. What one person sees won't necessarily be the same on every screen, so flexibility in layout and content is paramount. Look to the elements of style that you really can control, such as color, layout, and weight. Don't waste time on typographic nuances that work only on specific browsers at certain screen resolution on a particular OS. Above all, test everything to destruction.

Look at a newspaper. Most are designed on macroprinciples. They quite literally have content poured into them. Web typography should be addressed similarly in terms of content, layout, and style. Do it well and your readers won't notice. Do it poorly and they won't come back.

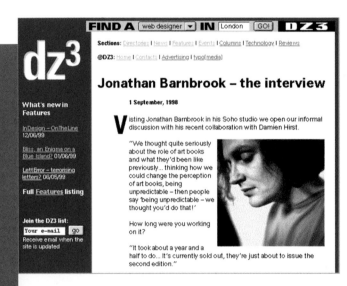

dz³

What's new in Features

InDesign – OnTheLine
12/06/99

Bliss, an Enigma on a
Blue Island? 01/06/99

LettError – terrorising
letters? 06/05/99

Full Features listing

Join the DZ3 list:

[Your e-mail] [go]

Receive email when the
site is updated

Jonathan Barnbrook – the interview

1 September, 1998

Visiting Jonathan Barnbrook in his Soho studio we open our informal
discussion with his recent collaboration with Damien Hirst.

"We thought quite seriously
about the role of art books
and what they'd been like
previously... thinking how we
could change the perception
of art books, being
unpredictable – then people
say 'being unpredictable – we
thought you'd do that!'

How long were you working
on it?

"It took about a year and a
half to do... It's currently sold out, they're just about to issue the
second edition."

Fontzone

New faces, new sites

28 May, 1999

House Industries has released the House-a-Rama Bowling Font
Kit, which includes three fonts, four patterns and a number of
dingbats. Rich Roat of House says that the design team was
inspired by a recent AMF Pro Tour and the golden age of bowling.
The font kit can be ordered online at House Industries site for
USD:100.00 (EUR:95.00).

Emigre has two new font families, John Downer's Vendetta and
Sibylle Hagmann's Cholla. Vendetta takes its inspiration from the
Venetian style, but mixes it with some influences from geometric
forms and legibility for screen. It's available in three weights and
includes "Petite" and small caps as well as fractions. Cholla is
available as a sans and a slab serif, in three weights. It is also
available in a "wide" and "unicase" version.

Peter Fraterdeus has launched Lettering.com as a focus for his
work in the lettering arts. This includes architectural inscription,
information signage systems and onscreen typography.

typeright "to promote typefaces as creative works and to advocate
their legal protection as intellectual property"

home | mission | features | contacts | insight | links

**Everyone Else
Has Rights**

By
Jack Yan

Email:
legal@typeright.org

Copyright law seeks to protect the effort
put in by creators of works, whether they be
designers, architects, artists, or musicians.
The effort, or the "sweat of the brow" as one
English court put it, is subject to protection in
most western jurisdictions. With the
development of computer software, the need
to protect intellectual property has become
even greater.

As TypeRight will inform you on other pages,
American law is sadly lacking in recognizing
the type designers' efforts. Type design has
as much effort as a melody of a song. And yet,
those who employ no effort aside from
filtering others' fonts through Fontographer
and selling them under new names can often
put up strong defences.

This is ironic, as the United States professes
to be the leader in the protection of
intellectual property. Type designers, instead,
have to go through the process of patent
registration.

In most Commonwealth and European

U&lc Online INTERNATIONAL
TYPEFACE
CORPORATION

FONTS U&LC ABOUT ITC SUPPORT TYPETALK

Home | Subscribe to U&lc | Reseller Locations | U&lc Media Kit | Change Address | Archive | Email ITC

Look at the Underside First *Bruce Sterling*

CRYSTAL
INKS

It's hard to kill a technology and keep it buried. "Thatching," for
instance. Once there was enough thatching going on in Britain to
make "Thatcher" a common name. Today, building a roof out of
wrapped-up marsh reeds is an aberrant thing to do; it houses
vermin, it slowly rots, it smells funny, it catches fire... But thatch
has returned in triumph to downtown London.

Shakespeare's Globe Theatre is back, from a vampire death of three and a half
centuries. It's built on the same spot, and in the same way, as the Bard knew
it – except for certain unavoidable changes. The walls are much stronger and
safer. The stairs and seats aren't so cramped and hazardous. And all the
thatch has been carefully chem-proofed, so that the thatch can't burn the
place down again, which is what happened to the Globe Theatre last time.

That's very odd, yes. But the charming tale of thatch is as nothing as
compared to the strange evolution of an old printer's darling, "lithography."
Lithography is two hundred years old. Utterly non-digital, it's all about
limestone, grease, ink and acid. Jules Cheret and Toulouse-Lautrec used to
hack this stuff. Fine-art lithography, the traditional craft that's still done with
ink sponges, rollers, wooden scrapers, and big iron squeezers, has never
quite died out – even though its fumes are now classified as health-hazards.

> www.dz3.com
> www.typeright.org
> www.fontzone.com
> www.itcfonts.com
> www.fontfont.de
> www.letterror.com

FontFont Finder Typographic Resource

Central News! Designers Categories Packages Free stuff Search

← previous
→ next

About Erik van Blokland

Erik van Blokland (1967) studied Graphic and Typographic Design at the Royal Academy for Fine and Applied Arts in The Hague, Holland. Another Dutch typedesigners. Erik started to collaborate with Just van Rossum under the name "LetTeRror" in Berlin, while working at MetaDesign, Erik Spiekermann's design studio.

After experimenting with computer programming in connection to type design, they came up with "Beowolf", the first typeface with a mind of its own. It was released by FontShop in July, 1990. The radical approach of Beowolf caused a lot of publicity for LeTterRor, and of course fame and fortune. Well, fame anyway. After stints at several places in the world, including David Berlow's FontBureau, van Blokland settled in the Hague as an independent designer, working together separately with van Rossum. Their work now includes type design, illustration, magazines, corporate design, interactive design, animation, music, and websites such as this. And lectures.

Beowolf
Hands
Kosmik
Trixie
Trixie Cyrillic
Zapata

central | new! | designers | packages | categories | search | where to buy

© Copyright FontShop International 1998

Clear text provides a clear identity, as these six examples prove. Type doesn't have to shout to be distinctive.

LettError Web **fonts**

Central [LttRRR | Exits | GifWrap | **WebFonts** | Typefaces]

The Gist Of It.

Current proposals to include fonts in the web do not address intellectual property issues properly. Fonts embedded in webpages can be taken out and used elsewhere by anyone who wants to. **OpenType** does not really change that, it just means another format that can be taken out with the same ease. Although the companies involved in webfonts, such as Adobe and Microsoft, talk a lot about 'protecting intellectual property', they do not have a clue on how to go about it. But they seem to be willing to risk their libraries anyway, by porting existing technology like pdf to a networked environment. Problems with font security that might have been acceptable in the office world scale up exponentially on the net and become a threat to the type industry.

The safety of embedded fonts in current proposals relies mostly on the honesty of the client software. Browser builders are kindly urged to not take advantage of the lack of protection, but that leaves a lot of opportunity to more dubious 'developers' to build utilities that suck fonts from webpages and present them in some usable format. It is naive to think this will not happen.

ネテスカ

4

イイテエネク

MSSGE

Reflection
105

а б ч

ФГЖЫЯКЛМН

ВЬХЗЙ

TY-

| 0 | 2000 | 4000 | 6000 | 8000 Miles (at Equator) |
| 0 | 2000 | 4000 | 6000 | 8000 | 10 000 | 12 000 Kilometres (at Equator) |

> WORLDWIDE AND LOCAL:

DESIGNING FOR
GLOBAL AUDIENCES
ON THE INTERNET

TEXT: LAUREL JANENSCH

For all the talk of the global village, the Web has remained a primarily local, and even elitist, medium. Huge American technology companies like Microsoft and Netscape have defined the look and feel of browser interfaces, while American Web shops have driven much of Web content and design.

But the "World Wide" in World Wide Web is finally starting to mean something: The number and diversity of global users coming online has increased exponentially, spearheading a rash of international partnerships by Web development firms, technology companies, and portal sites. Similarly, companies are seeing compelling business reasons for reaching out to new and diverse online markets: Forrester research predicts that global e-commerce sales will reach $3.2 trillion by 2003, representing almost 5% of all global sales. As Web sites become more global, the question of who a target audience is—identifying it, understanding it, and successfully communicating with it—has never been more important, or more complicated. Like it or not, all designers working in the field are being forced to recognize the myriad cultural and cross-cultural implications of the globalization of the Internet.

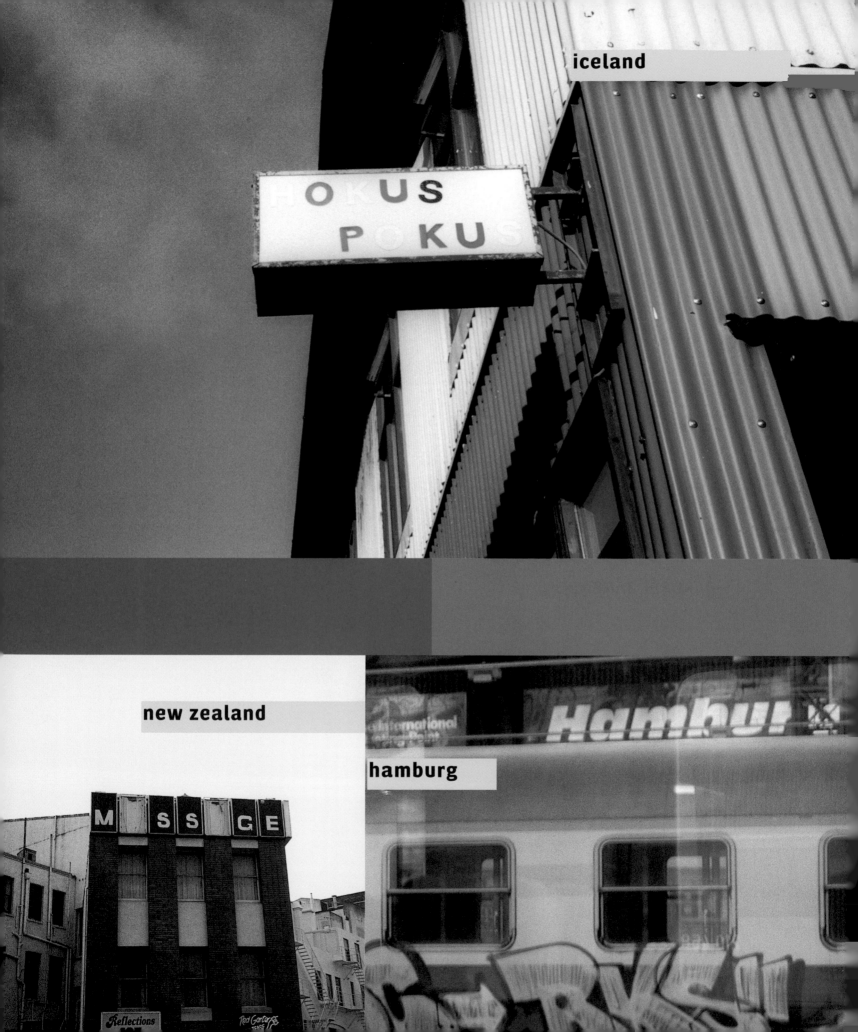

iceland

new zealand

hamburg

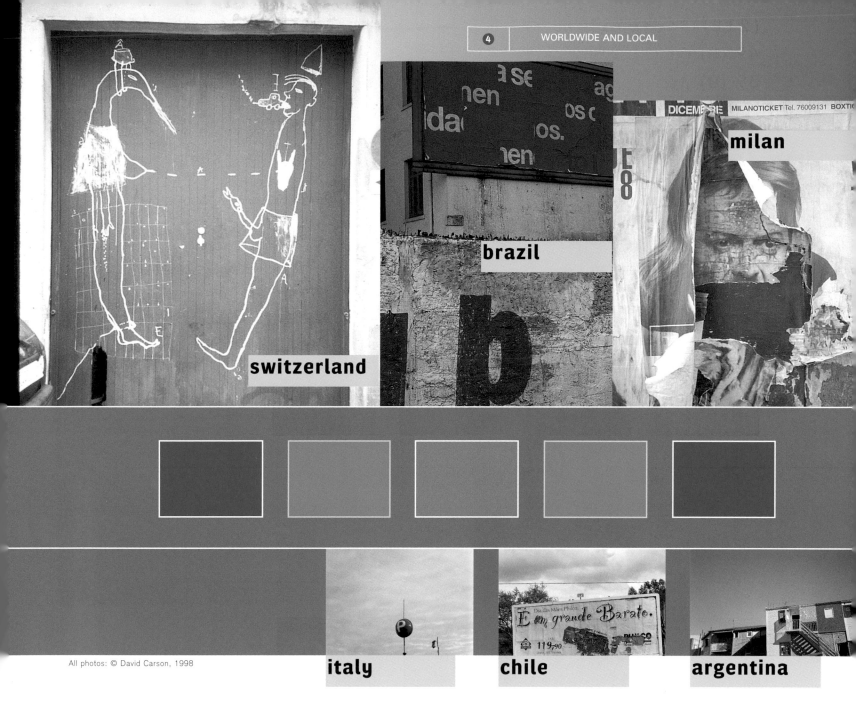

switzerland

brazil

milan

italy

chile

argentina

All photos: © David Carson, 1998

Like traveling in a foreign country where architecture, spatial orientation, language, and gestures all contribute to creating a new and sometimes disorienting environment, the Web is populated with content, language, design, and interface that can welcome or confuse users depending on their cultural familiarity with those elements. As experts in visual communication and as global citizens, how can designers prevent the Web from becoming a cacophonous Tower of Babel or, more ominously, a new form of cultural imperialism? Enter "localization," the process of modifying the language, content, interface, and visual design of a Web site in order to suit the tastes and requirements of a specific locale. This process is key to the future development of all international marketing and business expansion on the Web. "The goal of any product development, Web or not, should be for the user to feel that the product was designed specifically for him or her," says Barry Caplan, president of i18n.com, a localization consultancy whose clients include Autodesk and Intuit. "Given a choice of ways to access a product category or information, people will go for the most native-feeling product almost every time."

a GROWING FIELD

The localization industry, which ranges from small consultancies like i18n.com to large corporations like International Communications, originally grew out of the needs of software developers. This industry has already realized that integrating Web-site

(212) 333-3421 usa

49 (0) 6221 315026 germany

39 (0) 365 953481 italy

020 530 66 64 amsterdam

+44 (0)171 228 9223 london

421-95-622 1568 slovakia

513 33 60 mexico

かそすくう

ぬねひはてとあ

えきおちせいしさた

а б Ч Д И

Ф Г Ж Ы Я К Л М Н О П Р С Т У

В Ь Х З Й

カワスクワー
ケコナツニヌネヒハテトアエ
キオチセイシサタ

localization into their services is part of a natural evolutionary process. "The phenomenon we're seeing now is that there's a lot of convergence between traditional software applications and the Web," says David Brunton, Web and new media business developer at International Communications. "It's not always easy to draw a line between the two." But International Communications is not just a one-stop-shop—it partners with Web development firms who broker localization as a value-added service. As the Web becomes more global, Web development firms and localization companies are being forced to draw upon each other's complementary competencies.

the FUNDAMENTALS

Web-site localization may not sound very sexy—more pinstripe suit to Web design's black leather pants. In brief, the process starts with the development of a base strategy, architecture, and design that can be modified in order to create appropriate localized versions. The process of localization must then tackle technical issues like double-byte character conversion for non-Roman alphabets such as Japanese, Hebrew, Cyrillic, or Arabic; modifying address and phone number formats to follow national standards; and accommodating cultural preferences for color, style, and imagery.

In addition to these implementation issues, multinational companies have to consider how much localization is appropriate given a site's content as well as their own internal corporate structure. One model offers the consistency of a centralized approach: a heavy hand from the main corporate office, with little or no local content from subsidiaries or foreign offices. Conversely, decentralization allows for a range of solutions

Like many other portal sites, Sinanet's Web site uses a templated-grid formula.

through a loosely held network of locally designed and maintained sites with minimal involvement from corporate headquarters. "Clients have to decide how local they want to go," says Frank Cutitta, manager of international marketing at International Data Group (IDG). "Do you want to have a purely local site which is really French stuff developed specifically for French people with a French mentality. Or do you just want to have one big global site that happens to have translations at the global headquarters level?"

INTERFACE So where exactly does Web design fit into this scheme? Right in the heart of it. The point of overlap between localization and Web design is interface. Interface is crucial to the success of a Web site because it acts as a mediator, a translator, making the unintelligible zeros and ones of cyberspace understandable to us

- 經濟不景——在日中國人遭遇…
- 中國欠薪企業：國有企業占多數
- 牟其中被捕
- 經濟不景——在日中國人遭遇…
- 中國欠薪企業：國有企業占多數
- 牟其中被捕
- 經濟不景——在日中國人遭遇…
- 中國欠薪企業…
- 牟其中被捕

humanoids. When done well, interface compels users to interact with this invisible world as if it were "real" by integrating language, layout, standard formats, color, imagery, and metaphor with content to create a familiar environment and coherent user experience. This is where localization gets interesting.

LANGUAGE
ISSUES

One of the obvious issues involving the localization of a Web site interface is language. Just translate, right? Guess again. There are problems of dialects and colloquialisms within languages, and multiple scripts and text expansion across languages. Giant portal conglomerates like Yahoo and Excite were among the first Web sites to strive to reach diverse audiences by translating their content into other languages. While robust in local content, these and other portal sites often employ a template formula that maintains a consistent interface for all audiences. Sinanet, Excite's Chinese portal, illustrates in its homepage design how a standardized interface plus decentralized content allows for efficient and familiar, though uninspired design solution. A search field is front and center followed

"Throughout the region, people share a

part of a broader **Latin American community.**"

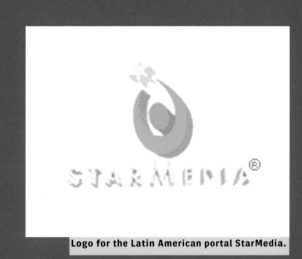

Logo for the Latin American portal StarMedia.

StarMedia creates a following by combining community–building features and regional content.

underneath by dynamically updated news items and nested categories. On top of it all, pages are doused with banner advertising.

CULTURE-as-BRAND Trying to associate its Web guide and search engine with Latin American culture, StarMedia Network has gone one step beyond the typical portal site. In narrowing its focus to both specific geographic regions as well as cultural affinity, StarMedia is positioning itself as an arbiter of Latin American culture on the Web. This site is a transnational exploration of culture-as-brand: It is geared towards the millions of members of the Latin American diaspora scattered across the Western Hemisphere, as well as people who share their interests and language. In order to earn the trust of its target audience, StarMedia must exceed the ubiquitous portal formula by adding levels of localization beyond language translation and a smattering of local content. Through chat, a Bulletin Board Service (BBS), and an Internet Guide that provides regional searches, StarMedia is striving to become more of an online community for the entire Latin American region, instead of further segmenting its users along a suite of country-specific mini-sites. "Though Latin America has long been divided by geographical and political boundaries, cultural similarities run strong," the Web site claims. "Throughout the region, people share a powerful desire to be part of a broader Latin American community."

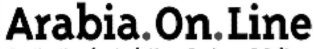
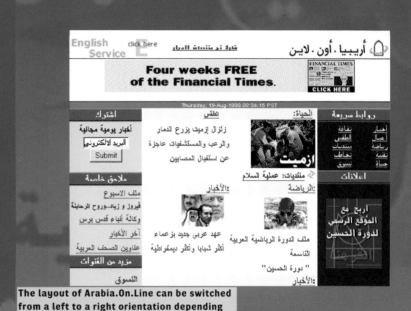

Logo for Arabia.On.Line, a regional content provider.

The layout of Arabia.On.Line can be switched from a left to a right orientation depending on whether users prefer English or Arabic.

READING and WRITING STYLES

Arabia.On.Line, a content site providing information on culture and news from the Arab world, aligns itself with both a geographic region and a cultural identity. Like many Arabic Web sites, Arabia.On.Line not only deals with the challenges of translating content between English and Arabic, but modifies the layout of the site to suit the right-left orientation of Arabic script. Says Khaldoon Tabaza, president of online services at Arabia.On.Line, "When producing English and Arabic language Web sites, design should be approached in a way to enable easy transformation of left-to-right designs into right-to-left ones in order to maximize design resources." Arabia.On.Line follows this imperative by implementing a symmetrical template structure: The three-column structure of the homepage design places the content in the middle and the navigation and promotional areas on either side of the page. Branding is at the top, the content in the middle, and navigation on the right or left depending on the language the user has chosen on the homepage. This effective yet

> www.arabia.com
> www.arabia.com/arabic/index.shtml

simple distinction permits the translation of the site, causing minimal disruption to the page design while accommodating differences in language and reading styles. This template-driven localization process also remains highly centralized, streamlining the production process.

SATELLITE SITES

Many corporate sites are opting for a balance between a centralized and decentralized approach to localization, or what Microsoft's COO Bob Herbold simply calls "global chassis, local body." IBM's Web presence is a perfect example of this two-pronged method. The main site contains content aimed primarily at an American audience, but links to local Web sites for the country in which IBM operates are accessible from a pop-up window on

A detail from IBM's homepage with the famous logo designed by Paul Rand.

The IBM headquarters' site establishes the design program for its local versions.

④ WORLDWIDE AND LOCAL

> www.ibm.com
> www.ibm.co.jp
> www.de.ibm.com
> www.ibm.co.il
> www.ch.ibm.com

Israel Japan Switzerland

IBM's design program allows for limited local interpretation.

the homepage, as well as through their own domain names. "The challenge for companies like IBM which have a lot of local content is that they have to address a lot of local needs," says John Grotting, creative director at Studio Archetype, a Web-development firm that has worked with IBM on various incarnations of its Web site. "Often, the local offices don't have the resources to develop their own sites. The U.S. is really the only place that does. So we made it simpler and more automated by developing a template system." The approach is to provide the worldwide offices with flexible templates and guidelines that reflect the design decisions on the IBM site; do away with most of the frills like daily updated graphics, content, or Java applets; and allow for localization of imagery and language. "But it's really up to the local country to decide how they want to handle it," adds Grotting.

IMAGERY
As IBM and many other global companies have discovered, color and imagery can be subject to pronounced cultural differences of interpretation. Mark Stevens, creative director at The Connection, a Web development firm in Hong Kong, has had some firsthand experience: "Colors are a big issue in China, especially with the older generation who tend to be more traditional in their beliefs," he says. "Lots of dark colors are unlucky.

Golds and yellows are lucky." But sometimes color is just a cultural preference without specific significance, like the prevalence of vivid colors in Brazil and Venezuela versus the more subdued color palette preferred in Germany. Imagery can also have a significant cultural impact. Often a component of desktop interfaces and icons, hand gestures are particularly dangerous. It turns out that the friendly "OK" sign, a common symbol in computer and Web interface design, means "You're an asshole!" in Brazil. Similarly, medical illustrations of pregnant women in Indian digital and print media refrain from showing nude female figures due to cultural and religious taboos; instead, a drawing of the fetus is superimposed on a woman's clothed body.

METAPHOR
One of the most fundamental elements of interface design, yet the most difficult to localize, is the central metaphor behind an overall site concept. Through user experience and design elements, metaphor references the familiar physical world of our daily existence, allowing us to

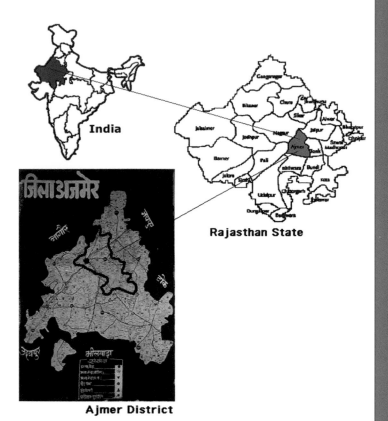

India

Rajasthan State

Ajmer District

This detail of Ajmer, a district of Rajasthan, India, shows the location of field visits made by an Apple research team attempting to develop a localized Hindi interface for the Newton palmtop.

This software keyboard with onscreen Hindi type permits electronic data entry and eliminates the traditional paper-based, hand-complied system of birth records.

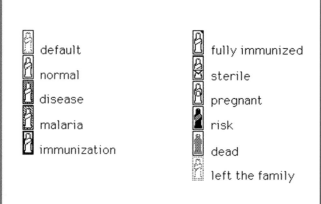

default
normal
disease
malaria
immunization

fully immunized
sterile
pregnant
risk
dead
left the family

The Apple research team designed a set of icons based on drawings made by auxiliary nurse midwives for illiterate birth attendants in Punjab.

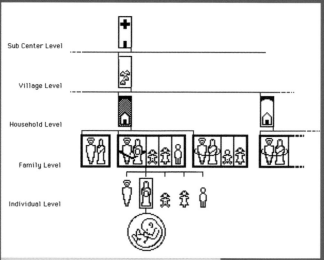

Sub Center Level
Village Level
Household Level
Family Level
Individual Level

An example of the Newton palmtop icons used in context to describe the birth records of a single household.

feel at home in the potentially disorienting virtual world of cyberspace. The importance of this was vividly illustrated by the success of the Macintosh desktop metaphor. However, even the metaphor of a desktop has cultural implications. Why couldn't it be a bus or a plow or a Buddhist temple? Why would a corrugated trash-can icon be appropriate in a culture that uses woven wicker trash receptacles? Clearly, localizing the overall metaphor for every global audience is a monumental and expensive task, as it often involves the most decentralization and, therefore, the highest expenditure of resources.

One would think that branding and product-oriented sites could justify this larger commitment, as they must closely tie in with regional differences in advertising campaigns, branding programs, marketing objectives, and local perceptions and preferences. However, current successful examples of this approach on the Web are few, if nonexistent. Several automobile manufacturers have experimented with different approaches to localization. Nissan has made some headway with a trio of Japanese, European, and American Web sites, each offering slight variations in its use of metaphor. While the European homepage contains image-oriented product information with a lead link about the groundbreaking design of a new concept car similar to a sales brochure, the U.S. site extends the company's American advertising campaign "Enjoy the Ride" by loosely employing a test-drive metaphor.

An even more forward-thinking example of the use of metaphor is found offline. In 1997, Apple sent a team of designers and technologists to work on the development of software for the Newton palmtop to be used by auxiliary nurse midwives, ANMs, in rural India. Immediately, the team recognized that its goal should be to provide the nurses with a intuitive way to maintain their extensive patient records. In the paper published by the Association for Computing Machinery, the team described their objectives for the interface design: "We needed to integrate the current abstract world of paperwork with the concrete world of camel bites and condoms, and make one reflect the other." In order to accomplish this task, the interface design had to reflect the nurses' cultural and professional preferences. The metaphor the Apple team employed was the complex series of task sequences that each nurse executed in her daily activities. Through hundreds of interviews and diligent storyboarding, each of these task sequences was mapped out to determine the navigational structure and content that the software should include.

LOCAL MINDSETS

Like so many other aspects of the Web, there is a noticeable range in quality of design, content, and interface, and, especially in the case of portal sites, a tendency to follow interface design "standards." Localized sites that are merely the "local body" of a larger design program often appear second-class when compared to the massive design and development efforts that are evident on the main headquarters site. Currently, localization on the Web appears still to be mostly about language translation and content. No one is making large leaps and bounds in alternative forms of interface design or metaphor. Imagery is underused, pages are text-heavy, design is minimal, metaphors and architecture remain the same. In addition, after you surf around to different localized sites, a pattern starts to emerge: Asia and Europe are consistently well-represented, but Africa and Latin America are not; wide swaths of the world population are still underrepresented. "Right now the Web is generic to English and U.S. standards," says Grotting. "But this is going to change as more global consumers who are less familiar with

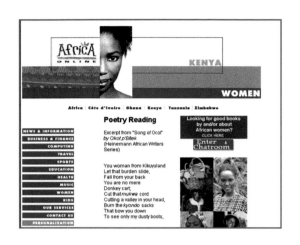

Africa Online is an Internet service provider based in Kenya. The company also has branches in Côte d'Ivoire, Ghana, and Zimbabwe.

the Web and computers in general come online." And they are coming. The total number of Web users in Africa, Latin America, and Eastern and Central Europe is expected to quadruple to 25.6 million by 2001. China alone will have more Internet surfers than any other country in Asia outside Japan by the year 2001, exploding to nearly 6 million by 2002.

GLOBAL GROWTH Already some of these non-Western global communities are using the Web to solve their own local needs. Studying these early efforts affords the opportunity to learn firsthand about the technical, cultural, and national preferences of these new users. African Web sites provide several good case studies. "There are many thousands of isolated examples of the ingenious uses to which low-cost communications are already being put," says Mike Jensen, an expert on Internet connectivity in Africa, about Web sites produced on the continent with the most rapidly expanding population. "But because of the high cost and slow speed of Internet connections, sites must be low bandwidth and utilitarian, and provide mostly text-based content of local interest." For now, text-based content on Web sites and in email services allow Africans with limited technology to take advantage of some of the most profound and useful aspects of the Internet without getting hung up by large downloads. For example, farming cooperatives in Kenya, newspapers in Ghana, government offices in South Africa, and craftspeople in Niger are all finding ways to use the Internet to get better produce prices, publish breaking news, inform citizens about government services, and export crafts. Setting a good example, Jensen is already thinking about how interface design might be affect-

> www.africaonline.co.ke
> www.africaonline.co.ke/africaonline/coverwomen

ed by the next wave of online Africans. "Africa is generally recognized to have a more aurally oriented culture, so the multimedia interface will become more important," he says. The implications for design in light of this cultural preference for spoken over written words could be profound.

The awareness of the possibilities, as well as the pitfalls, of designing Web sites for diverse global audiences is the first step in developing personal as well as corporate strategies for determining how to integrate localization into the Web development process. The process of exploring different interface possibilities in coordination with analysis of a site's target audiences isn't so different from what normally happens in the life of the designer. It's simply more intense and, to some extent, more humbling, since a designer must depend on so many others to supplement his or her own experience and knowledge. But working on cross-cultural Web projects can have its upside, too: Through exposure to other cultures' visual systems and collaboration with designers, users, and cultural experts our creative energies will be renewed and expanded. For Mark Stevens, his experience in Hong Kong has had both humorous and inspirational moments. "You start to understand Eastern fables, stories, happenings, beliefs. . . which can open up whole new avenues of creativity for you," he says. "It can be amusing coming up with a 'Chinese' thought and then watch the look on your clients' faces when they know you're 'on to them.'"

EDUCATION AND

SPECIALIZATION:

WHO ARE TOMORROW'S
DIGITAL DESIGNERS?

TEXT: JOHN MAEDA

We've heard the complaint before—"Our engineers can't communicate with our designers, and vice versa." Successful design for electronic media, as defined today by the World Wide Web, is the result of the combined effort of a commonly configured team of designers and engineers.

One side envisions; the other side builds. Usually, the side that builds doesn't particularly respect the other side's professed superior imagination. And the group whose duty it is to invent usually looks down on the manual labor of its compatriots. Which side is comprised of designers and which of engineers is not completely obvious. Indeed, you can look at the distinction from either perspective and find that the referent for "visionary" or "builder" is not absolute. In my opinion, neither side is more creative, nor skillful, than the other.

In this project titled "Telnevision," student Ben Fry redesigned an image lifted from TV and filtered it through animated letterforms.

When a conflict occurs, the designer might try to defend his position by citing the hallowed rules of typography. The engineer, on the other hand, might try to prove his point by noting a passage in some cryptic book of programming languages. The manager of this production team usually has quite a challenge keeping the lines of communication open, a complicated task compounded by the fact that industry standards keep changing, and new hardware and software must be bought every month. How do you keep everyone working together? Is there a solution in sight?

There is a solution, though it may be a bit drastic. Simply fire those who are adamant in taking sides. A new generation of hybrid designer/technologists will hit the scene over the next decade. These hybrids are young, energetic, and capable. And they can optically center a line of type by hand and then write the code to do it automatically the next time.

a NEW BREED How are such professionals created? For the most part, they create themselves. A decade ago, industry and academia used to be the only places where people could aspire to computing fluency. Today, high school students learn C and JAVA either in class or in their spare time; some of them even have Web servers in their basements! The societal impact resulting from this early dose of technofluency is remarkable—by the time they get to college these youngsters are less interested in computers and more in how they can influence society at a cultural level. In school, they quickly learn the hard lesson that the agendas for improving technology are already set in place—for the sake of technology, not humanity.

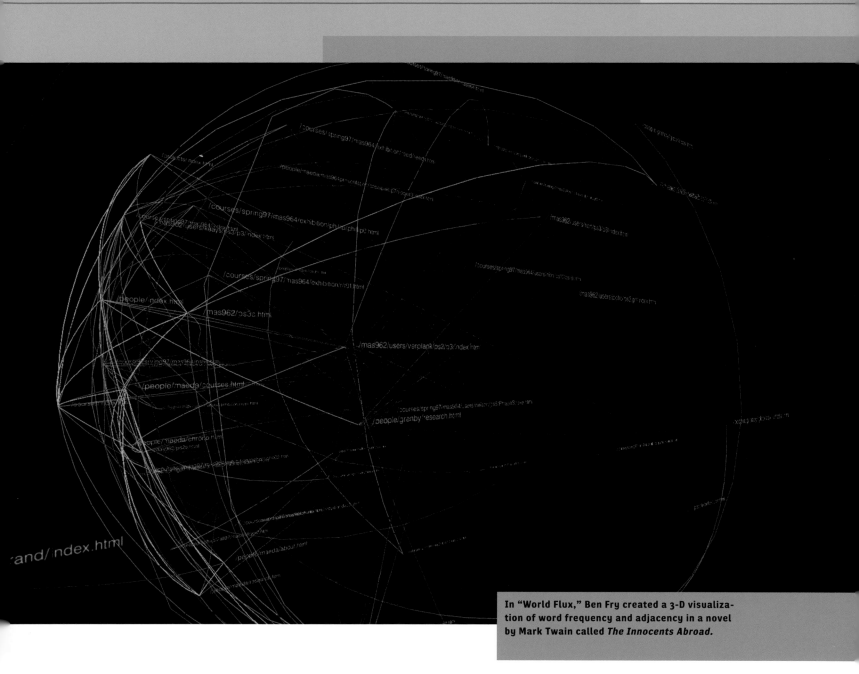

In "World Flux," Ben Fry created a 3-D visualization of word frequency and adjacency in a novel by Mark Twain called *The Innocents Abroad.*

DESIGN ENGINEERS

As director of the Aesthetics and Computation Group at the MIT Media Laboratory, I find we attract students who don't fit neatly into the categories of either designer/artist or engineer/scientist. This is not owing to a lack of talent on their part. They don't want to just write code or just create illustrations—they want to do both. At MIT, we've attempted to encourage a hybridization of talent by nurturing students' abilities in both design and technology. You might argue that we develop less of a designer or engineer in the process, but I believe that these students are even better prepared for problem-solving: They are multifaceted individuals who can be more than twice as effective in any creative information design task. In an age where technology affects a change in digital design practices almost everyday, we need people who not only understand the fundamentals of why these changes are occurring, but who also can address any situation in a thought-

Student Golan Levin designed a fluidly animated paint program called "Floo."

ful, appropriate manner. This approach may hark back to William Morris and John Ruskin and their regard for the versatile craftsman in the wake of machine-age specialization. However, the point is not to step backward as if to deny progress, but to find ways to leap forward by making best use of the technology available to us today.

One assignment recently given to our students involved the creation of a labwide online information base that could automatically generate pre-press materials ready for printing. All software was built from the ground up, and the task of creating a small book was completed in a week. I should note that the last two days were spent hand-tweaking the auto-generated results—a sign that the students knew what could and what couldn't be done automatically, and that they had the manual and visual skills to "fix" whatever emerged. While the result won't win any design awards, the level of efficiency that the students achieved was amazing. One student wrote the necessary PERL scripts to process and "clean" the data and another wrote more PERL scripts to "harvest" the data. The data was then input by the students into another system in PERL to create Illustrator files that were instantly gathered and coerced into a QuarkXPress document. Usually, when such a process is described to outsiders, their first reaction is, "But who were the designers?" The students were the designers. All of the group's esthetic and information design decisions were made in tandem with a knowledge of the limitations of the automated systems they created, thus resulting in a more efficient solution.

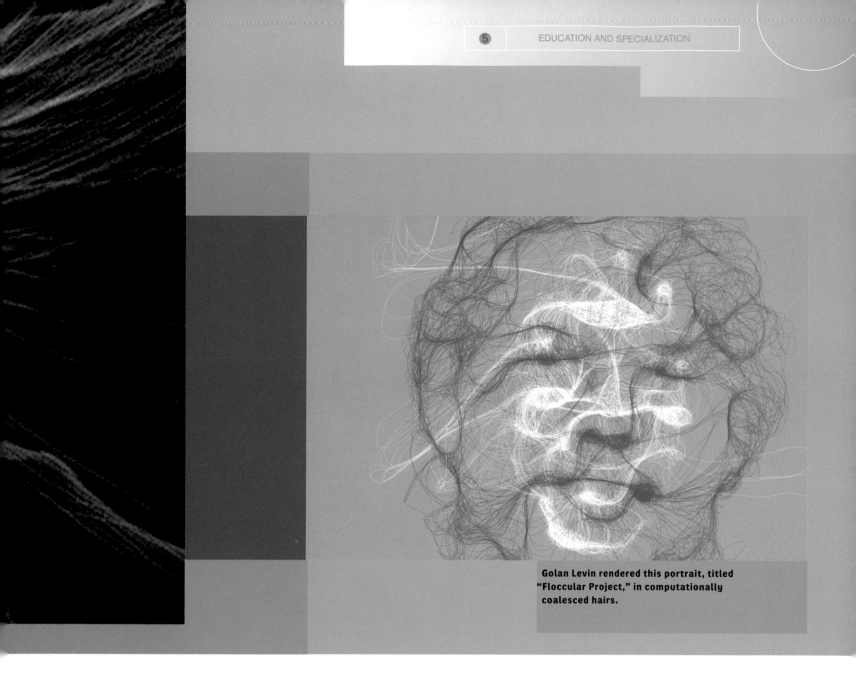

Golan Levin rendered this portrait, titled "Floccular Project," in computationally coalesced hairs.

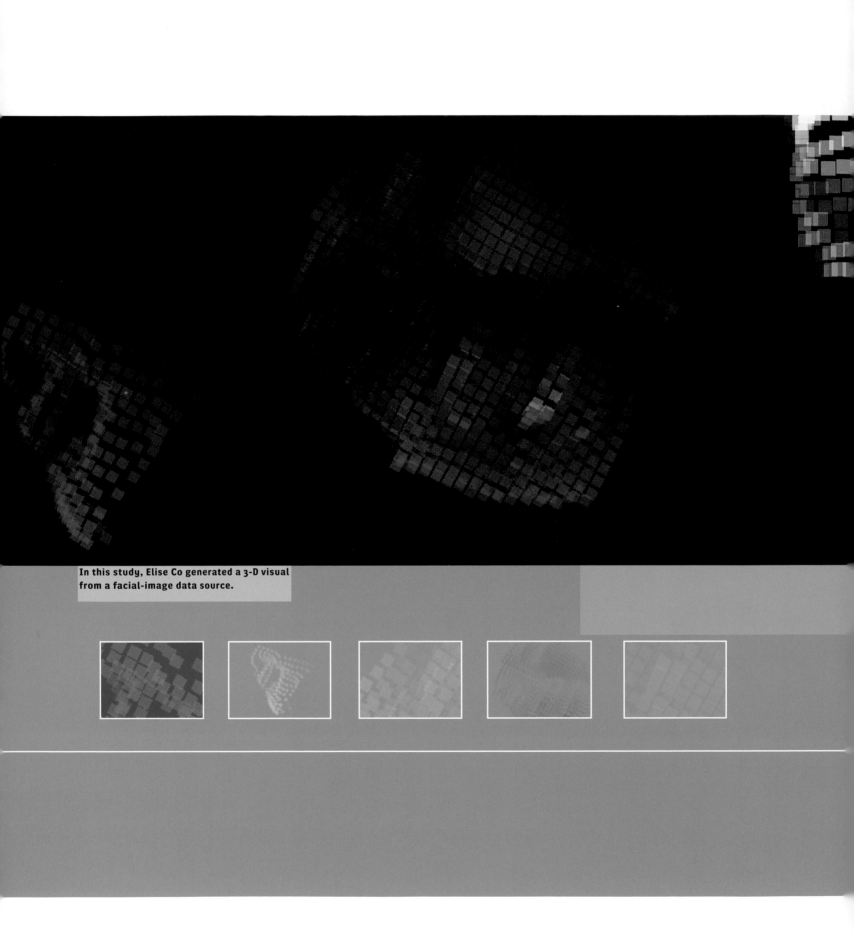

In this study, Elise Co generated a 3-D visual from a facial-image data source.

In "Flowing Words," developed by student Tom White, trickling letters become a stream of text mimicking the motions of fluid.

With this 3-D rendering, student Bill Keays created an exaggerated study of the impressions of a hand on fabric.

NURTURING TALENT

One might ask, "How do you educate such students?" Refining raw talent is clearly a challenge when the discipline itself is not well-defined. At MIT, we've attempted to develop a curriculum that could provide the basis for a methodology. At the graduate level, we maintain a studio atmosphere where our focus is on developing students' individual esthetic intuitions and working to ensure that they have the technical skills necessary to realize their visions. At the undergraduate level, areas such as image processing, computational geometry, and physical simulation are offered in tandem with exercises training the students to see and, most importantly, synthesize in the visual domain. So far the results have been promising.

The idea of the perfectly integrated designer/technologist may seem overly optimistic and there are, of course, some significant problems with this approach. First, there are no strong academic programs to challenge the people who can fulfill this objective. Second, even if you find these truly gifted people, you aren't sure exactly what to do with them.

INADEQUATE OPPORTUNITIES

Why aren't there any academic programs that nurture a hybridization of design and technology skills? The answer is that there are no properly qualified instructors to teach this kind of tightly integrated discipline. If any such instructors did exist, they would probably choose to commercialize their skills because they wouldn't be able to find a position in academia. It is true that there are many design programs worldwide

that have ventured into digital design and made the tremendous investment necessary to create new-media programs, purchasing first-class equipment and "big name" instructors. However, a solid academic program must be created with fundamentals, not funds. Students who have grown up at familiar ease with the computer quickly surpass the skills of the so-called experts. Also, students often waste the majority of their four-year programs learning how to use computer software that soon becomes obsolete. This does not bode well for a constructive future in the field of design. There must be an emphasis on the most basic issues in design and technology in order to guarantee a productive next generation.

CREATIVE DISCIPLINE

If by some miracle you are able to round up a group of young, open-minded designer/technologist types such as we have at MIT, your next responsibility is providing them with suitable challenges. One of the most formidable tasks we've found is to encourage students to resist science and technology and, at the same time, resist conventional art and design. The problem with technology is that there is no end to the kind of metamanipulations on information that one can engage in, which in itself is a seemingly esoteric, yet highly utilitarian, form of artistic endeavor. In other words, it is easy to get caught up in making the ultimate creation. Most people in technology get trapped in this kind of thinking because they perceive great

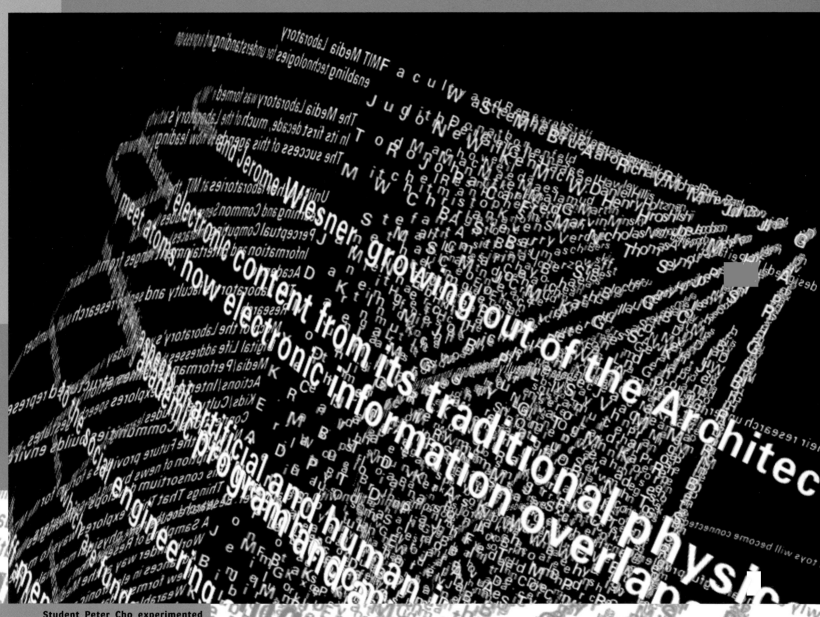

Student Peter Cho experimented with motion in 3D with a swirling text for the MIT Laboratory.

In "Solid Light Display" by student Bill Keays, fiber optics transform incoming video pixels into a sculptural entity.

beauty in the tool itself. When dealing with pure computation, as regards art and design, it is easy to yearn for the familiar comforts of the physical, as opposed to virtual, space. Painting with pigment on canvas or carving in stone provide a more immediate, sensual experience for the artist than does a cold mathematical equation. Also, students often feel some frustration at their inability to accurately describe their projects with everyday language. No vocabulary, besides computer code, can specifically illustrate their creative experiences.

DOUBLE OR NOTHING

The biggest problem our students face is that, after graduation, they have no place to work. Certainly, they have many employment opportunities, but the kind of work they do spans many fields, and does not necessarily lend itself to joining the "design" division or the "technology" division of some corporation. You might want to call them "integrators" but that is somewhat denigrating. Their knowledge, instead of being thought of as a specialized hybrid, is rather a broader and deeper understanding of the potential of technology on a variety of levels. I consider those who are encouraged to specialize in either design or technology less the products of free will and determination than the products of a deficient educational system.

line

If you get lost or stu
use the bottom nav

line: returns to the
map: shows a map
mail: gets your mai

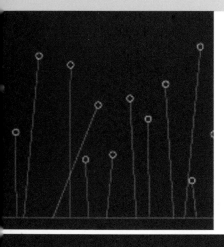

You have new Mail

 6

- ⊟ Crawler
- ⊟ Map
- ⊟ HTML Stream
- ⊟ Extract
- ⊟ Stash
- ⊟ Dismantle

- →] Crawler
- →] Map
- →] HTML Stream
- ⤷ Extract
- ⤷ Stash
- ⤷ Dismantle

6

>

"The screen is my line in—and my line out." —Melinda Rackham

END OF THE LINE:

EXPERIMENTAL AND NONLINEAR INTERFACES

TEXT: STEVEN HENRY MADOFF

It couldn't get much simpler. A line floats in space, red on black. It turns slowly, revolving on its invisible axis, but there is always, of course, a beginning and an end, Point A to Point B. Nothing could be more straightforward, or so you would think.

But then you click and enter, for this is just the opening screen of Melinda Rackham's online art piece, plainly titled "Line." And what lies beneath or beyond that simplest of entries is a series of elliptical email exchanges about love and loneliness, about the weather and the Web, and a dozen other subjects meandering lazily, click after click after click.

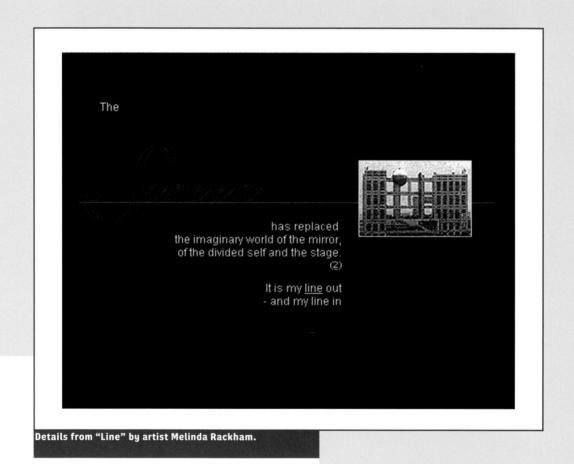

The

Screen

has replaced
the imaginary world of the mirror,
of the divided self and the stage.
(2)

It is my <u>line</u> out
- and my line in

Details from "Line" by artist Melinda Rackham.

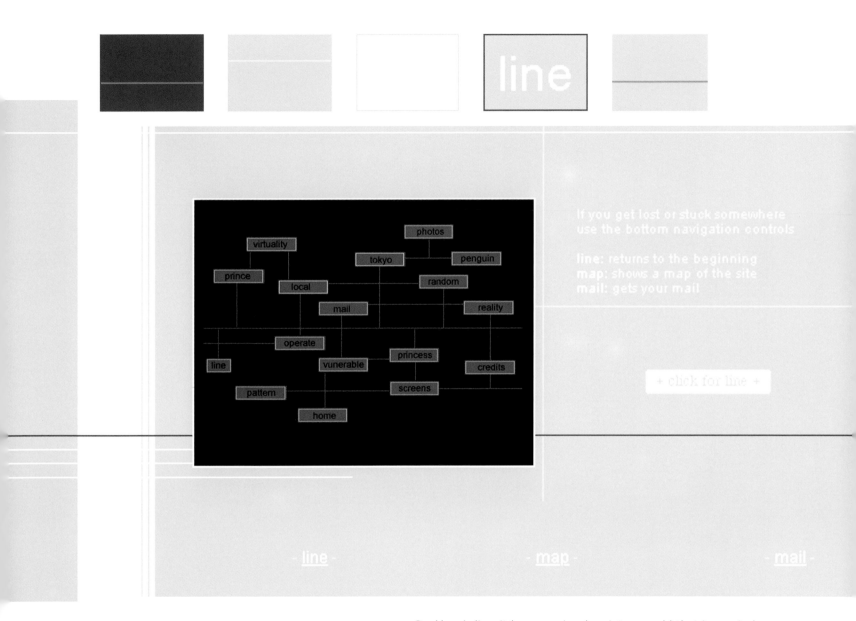

If you get lost or stuck somewhere use the bottom navigation controls

line: returns to the beginning
map: shows a map of the site
mail: gets your mail

+ click for line +

- line - - map - - mail -

Rackham's line, it happens, is a lure into a world that is precisely its opposite, a decidedly nonlinear domain. Its wandering narrative is familiar to any denizen of the Web, empowered by the Internet's most basic time-bending and space-eating tool: the hyperlink. In fact, the hyperlink is nothing less than the millennium's engine of change for the way that the world knows things and sees things. And for artists, knowing and seeing in this particular way is what has made the Web a teeming laboratory and playground of infinite dimensions.

"BEYOND interface" Rackham's piece is only one of two dozen in the Walker Art Center's exhibition "Beyond Interface," an online collection of Net art now part of the Walker's Digital Arts Study Collection. This mad circus of designs asks, among other questions, what narrative means when a story no longer pulls you straight from A to B. For anyone who has taken more than a second look at the art

From:<rorg@corp.co.jp>
Date: Fri, 31 Jan 1997 08:49:37
-0500
To: em@web.com.au
Subject: sweetie

sweetie,
sweetie sweetie ?
sweetie, sweetie sweetie, *sweetie*, sweetie-sweetie !
sweetie SWEETIE...
sweet-ie... (sweetie/sweetie !)...
sweetie,
sweetie-sweetie
... lvu

More Mail Reply Close Mail

More details from Rackham's "Line."

of this century, of course, that is an old question. Cubism's multiple perspectives and sur-realism's subconscious mutations of logic—its fur-lined teacups and melting clocks—ask much the same thing: Isn't it truer to the chaos of modern life to see the world as a con-tinual upheaval of simultaneous events, the random and the planned, the conscious and subconscious endlessly colliding. But then Susan Hazan, in an essay accompanying "Beyond Interface," raises the historical ante still higher when she writes that "hypertext consciousness . . . existed before books, before scriptures, before the invention of God." She goes on to say that books have made us all "enslaved readers" in the largest sense: Our very nervous systems have been conditioned by the "artificially restrained paginality" of the book. Translation? We're chained by the old narrative flow that dates back more than a thousand years. Embrace hypertext consciousness and be freed.

the HYPERLINK Whether it's freedom or not, whether digital design takes us somewhere grander existentially, are questions too large to answer anytime soon. But what's clear is that hyperlink technology is an immensely potent tool that brings the

You have new Mail

Netscape: -+- :Mail

From:<hot@hotmail.com>
Date: Tues, 03 Jul 97 13:33:20 EST
To: em@web.com.au
Subject: Tiffany's Pictures on her web page

If you are not interested in adult pictures or are under the age of 18, I apologize, DO NOT REPLY and I will GUARANTEE you will be removed from my list or you may reply to removetif@cumtome.com and you will receive confirmation that you were removed, either way, I apologize and you WILL be removed from my list.

Hi my name is Tiffany. I am a college student that just learned how to make a web page, so I decided to put some naughty pictures of myself on my page for everyone to see. If you want to see it, write back to me at tif@cumtome.com and type "over 18" in the subject box (you will have to change the current "to" box to tif@cumtome.com)

If you are offended by nudity, Do Not Reply and I will take you off my mailing list.

- Tiffany (7)

More Mail Reply Close Mail

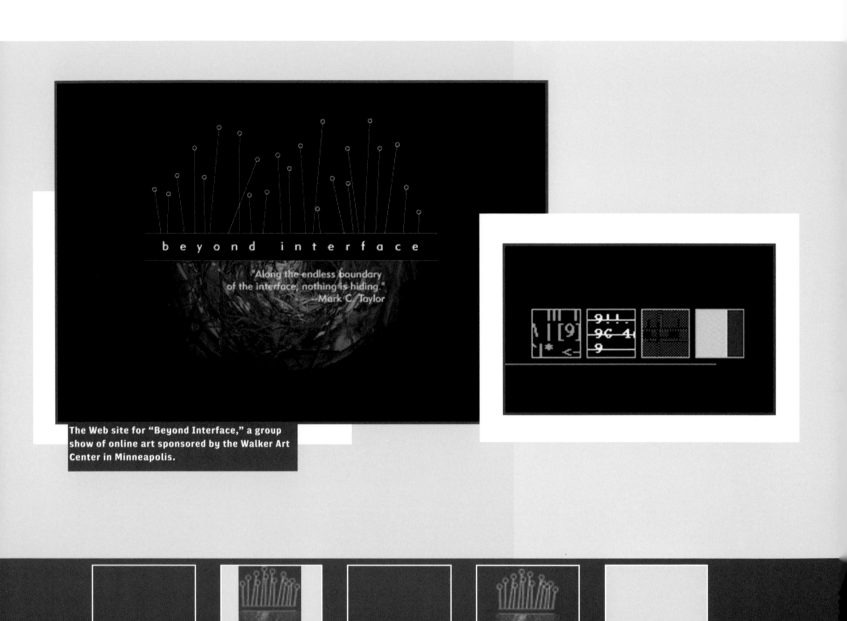

The Web site for "Beyond Interface," a group show of online art sponsored by the Walker Art Center in Minneapolis.

>www.walkerart.org/gallery9/beyondinterface/

notion of the multiple and the nonlinear view of the world into the mainstream. Anyone who uses the Web by simply clicking from one site to another experiences it without the slightest conscious effort. And what is equally clear is that artists are using the medium of the Web to push the issue of the nonlinear as far as it can go.

JODI

Consider the most famous art site on the Net, the work of Joan Heemskerk and Dirk Paesmans known as JODI. JODI is a refutation of the linear, of that old "paginality." If Heemskerk and Paesmans intend anything—and it's difficult to decipher much of JODI's mad-making, subversive screens—they intend a supremely overheated antinarrative. Click at your own risk on the miniature browsers that suddenly overrun your monitor; the meaningless lists of machine addresses; the cathode-green litanies of code gibberish that stream endlessly and will quite likely crash your machine. Nothing makes sense in a linear way. You've stepped into modernism's dare to the viewer to look at the world not as a unified whole but as a collection of fragmented events and experiences—instantaneous, disorienting, and often incoherent. With JODI's fierce use of technology, the dare becomes extreme: If you enter the site, you're sucked into a jacked-up hypertext consciousness so deep into its own obscure logic that there is nothing, in a figurative sense, to hold onto.

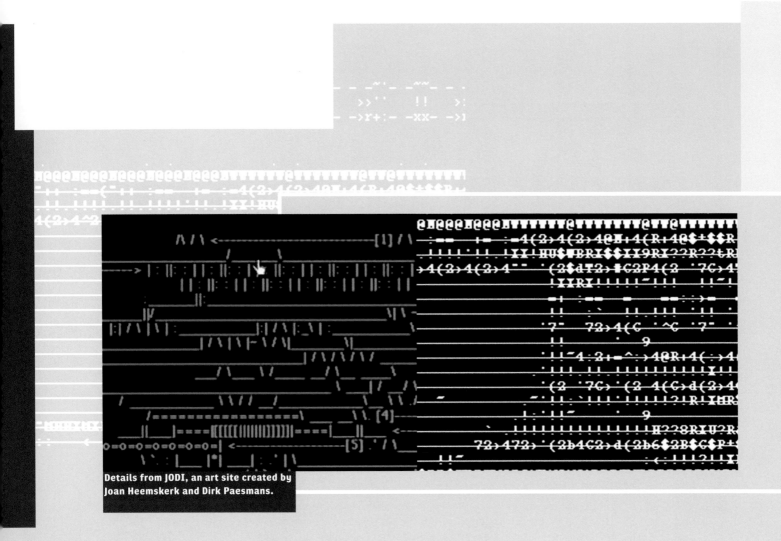

Details from JODI, an art site created by
Joan Heemskerk and Dirk Paesmans.

"We explore the computer from inside and mirror this on the Net," JODI's creators say. "When a viewer looks at our work, we are inside his computer. You are very close to a person when you are on his desktop. We think the computer is a device to get into someone's mind." The end of this line, if you think about it, is that there is no end: The misrule of the subconscious is mapped onto the machine; the subconscious of the machine is mapped onto the network; the network is envisioned as a landscape without gravity or nucleus.

visual THESAURUS That is where you find yourself in Plumb Design's *Visual Thesaurus*. There is no terra firma here; no beginning, middles, and ends. You're floating in a sea of words in perpetual motion. You click and gather assortments of like terms that bob up, turning from pale gray to black as they're momentarily magnetized by your interest. At first, the way the *Thesaurus* works is utterly disorienting. It is as mobile as the mind, as fluid as

> www.jodi.org

%20Demo

:maddick
. macro.7
;mx.335
-monkey

Museums
and the Web
1998

plumbdesign

plumbdesign

live through

mental object

content

participate

take part

experience

go through

know

undergo

cognitive content

education

horizon

noun

adjective

verb

adverb

VISUAL THESAURUS

experience

DISPLAY : ○ AUTO-NAVIGATE

◉ 2D ○ 3D

CREATED USING TH!NKMAP COPYRIGHT 1998 PLUMB DESIGN, INC

**Screen shots of the *Visual Thesaurus* designed
by New York City's Plumb Design.**

> www.plumbdesign.com

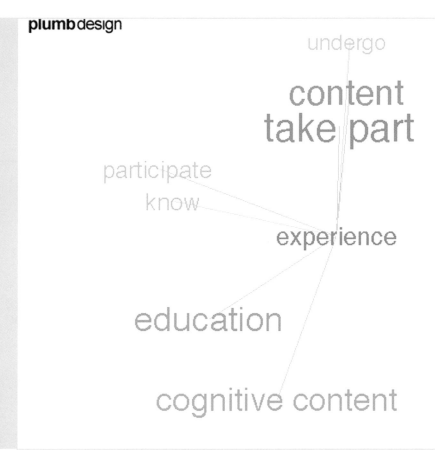

the stream of consciousness that James Joyce first evoked in *Ulysses* and then turned into a river of night thoughts, of protohypertext, in *Finnegans Wake*. And like that sense of dreaming, the meanings and relationships of words in the *Visual Thesaurus* take on a weightless flow that seems to mimic the subconscious and have nothing to do with the anchored stability of the printed page's orderly progression. But, of course, that's the *Thesaurus*'s dynamic principle: its assumption that the world is based on the instantaneous, the daily power of chance and the relations it creates.

WEB STALKER I/0/D's Web Stalker is another case of insurrection, a kind of dreamworld browser, offering up infinite, relative connections. There are no dancing graphics on the Web Stalker—in fact, it doesn't read graphic files (or sound files, for that matter) at all. What it visualizes is the relation of connecting sites as a scheme of plain circles and linking lines. The Stalker is about nothing but these passing relations—or more generally, about the massive relativity

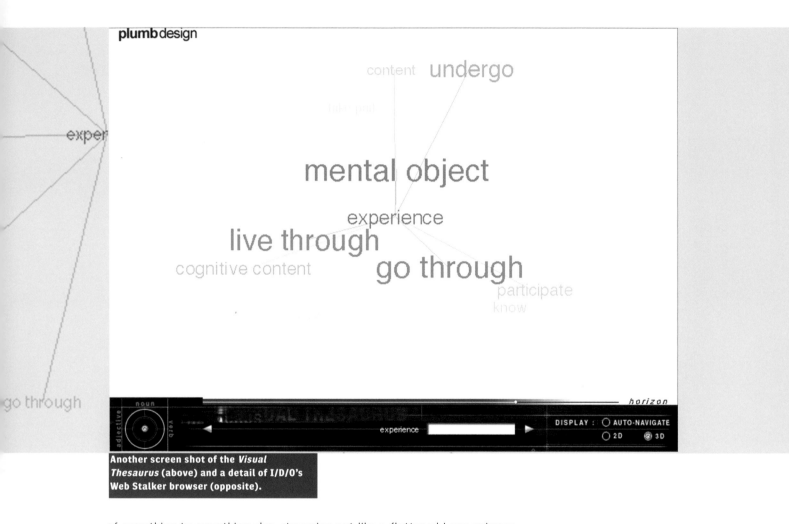

of everything to everything else, streaming out like a flattened Lego universe mutating with every click. Matthew Fuller, one of the Stalker's creators, describes its view of the Web as one of "radical coefficiency." This means that the Stalker is a leveler, giving equal weight to each site across the whole vastness of the Net. No less radical in its way than JODI, the Stalker literally eradicates all the elements of a site's content except its text, which it dumps into a file. What the user sees is something like an interactive minimalist drawing of the network itself that, like the credo of minimalist art, is all about its "truth in materials."

Fuller makes the claim that the Web Stalker falls into a category he imagines called "not just art." He thinks of his browser as an artistic conception and as a tool, a mutant form that takes the entire Net and its myriad sites as his clay to mold and also as a cool piece of engineering that works.

> www.backspace.org/iod
> www.plumbdesign.com

Complete http://www.labour.org.uk/join/index.html [4729 of unknown] O : OK

Crawler

o://www.labour.org
/graphics/line_spac
0x5.gif

http://www.labour.org.uk/join/index.html

smantler

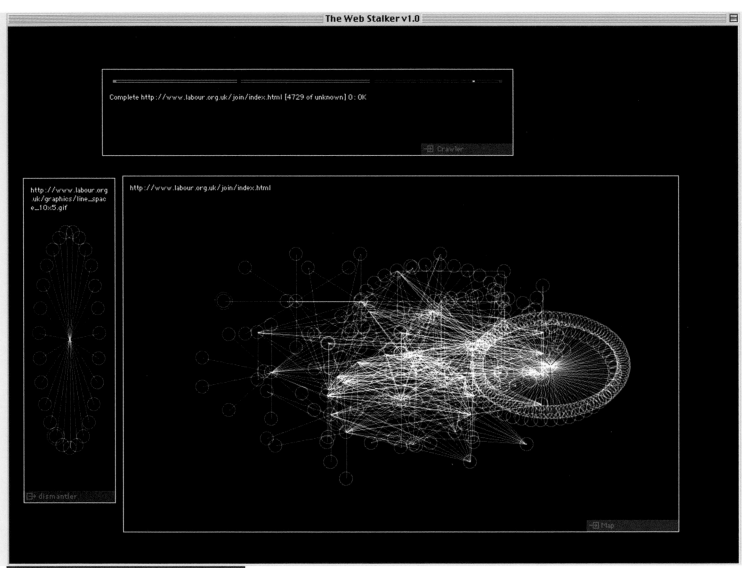

More screen shots of I/D/O's Web Stalker browser.

It is "not just art" because it has a social aspect. It gives people an implement of change; an implement that reaffirms the nonlinear, the relative, and the multiple, and does so as a powerful enabler through Web design.

I recently spoke about all of this with Anthony McCall, a vanguard English filmmaker of the '70s and founder of the New York graphics studio Anthony McCall Associates. Himself the creator of a strange floating thicket of text called "The Kiss," McCall is both amused and philosophical about what artists on the Web are doing. "We're just in the horseless-carriage stage," he said. "The Web is a poor cousin to all the mediums that it integrates: bad picture quality, bad sound quality, bad print quality. And yet, because of its connectivity, it's quite staggering."

"Yet I really do see the print-based world inevitably being thrown off to the side," McCall continued. "It isn't that it's going away—old mediums tend to fight back and renew themselves. But for kids, the world is increasingly screen-centered, not page-centered. It's all about being time-based, about being fluid and moving. The page can't do that. It can't keep up."

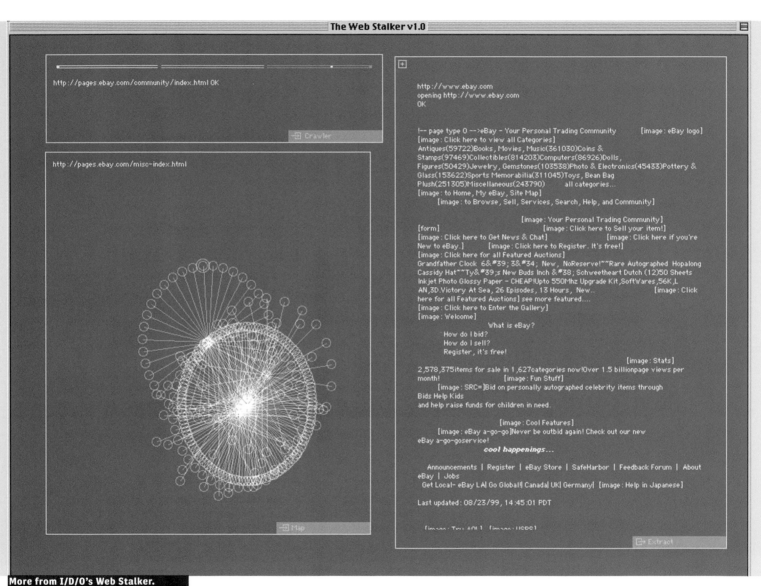

The Web Stalker v1.0

http://pages.ebay.com/community/index.html OK

⊞ Crawler

http://pages.ebay.com/misc-index.html

⊞ Map

http://www.ebay.com
opening http://www.ebay.com
OK

!-- page type 0 -->eBay - Your Personal Trading Community [image : eBay logo]
[image : Click here to view all Categories]
Antiques(59722)Books, Movies, Music(361030)Coins &
Stamps(97469)Collectibles(814203)Computers(86926)Dolls,
Figures(50429)Jewelry, Gemstones(103538)Photo & Electronics(45433)Pottery &
Glass(153622)Sports Memorabilia(311045)Toys, Bean Bag
Plush(251305)Miscellaneous(243790) all categories...
[image : to Home, My eBay, Site Map]
 [image : to Browse, Sell, Services, Search, Help, and Community]

 [image : Your Personal Trading Community]
[form] [image : Click here to Sell your item!]
[image : Click here to Get News & Chat] [image : Click here if you're
New to eBay.] [image : Click here to Register. It's free!]
[image : Click here for all Featured Auctions]
Grandfather Clock 6'3" New, NoReserve!~~Rare Autographed Hopalong
Cassidy Hat~~Ty's New Buds Inch & Schweetheart Dutch (12)50 Sheets
Inkjet Photo Glossy Paper - CHEAP!Upto 550Mhz Upgrade Kit,SoftWares,56K,L
AN,3D.Victory At Sea, 26 Episodes, 13 Hours, New.. [image : Click
here for all Featured Auctions] see more featured....
[image : Click here to Enter the Gallery]
[image : Welcome]
 What is eBay?
 How do I bid?
 How do I sell?
 Register, it's free!
 [image : Stats]
2,578,375items for sale in 1,627categories now!Over 1.5 billionpage views per
month! [image : Fun Stuff]
 [image : SRC=]Bid on personally autographed celebrity items through
Bids Help Kids
and help raise funds for children in need.

 [image : Cool Features]
 [image : eBay a-go-go]Never be outbid again! Check out our new
eBay a-go-goservice!
 cool happenings...

 Announcements | Register | eBay Store | SafeHarbor | Feedback Forum | About
eBay | Jobs
 Get Local- eBay LA| Go Global!| Canada| UK| Germany| [image : Help in Japanese]

Last updated : 08/23/99, 14:45:01 PDT

[image : Try AOL] [image : USPS]

⊞ Extract

More from I/D/O's Web Stalker.

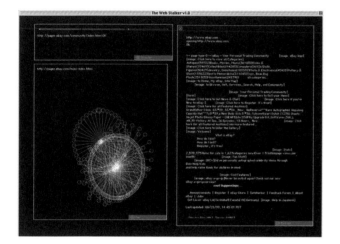

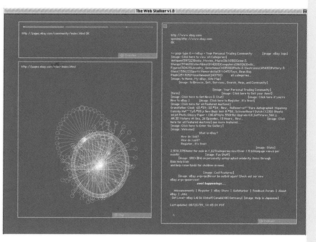

the **TOTAL ART FORM** The inevitable question is: Where next? If the hyperlink is the engine driving so much art that mirrors our increasingly nonlinear, networked world—a world of a trillion databits and voices careening invisibly across the globe, each with its own momentary narrative—then where does the hyperlink lead us? Where do these early art sites like Rackham's "Line," like JODI and the *Visual Thesaurus* and the Web Stalker point us? And I would say backward, in a sense, and forward. Backward, because I'm thinking of the old 19th-century concept of the *Gesamtkunstwerk*; the term that Richard Wagner used to describe a total art form, melding scenic art, song, poetry, dance, and drama. Forward, because I'm thinking of the current technobuzzword "convergence." Suddenly, it seems, they're moving toward each other at the speed of light. Indeed, convergence is the technological equivalent of the artistic *Gesamtkunstwerk*. The conglomeration of rising Internet speeds, growing bandwidth that accommodates rich data files, faster processing that smoothly streams video and sound, and software that excels in every aspect of studio craft make the cyber-*Gesamtkunstwerk* possible. And unlike Wagner's 19th-

> www.narrativerooms.com/studio/kiss

Details from "The Kiss" by Anthony McCall.

century theater, locked into a physical place, the cyber-*Gesamtkunstwerk* will take every advantage of the hyperlinked network. It is easy to envision islands across the Net of linked artworks blending animation, voice, still photographs, video, and text. Multiple narratives, random interjections, flights of abstract imagery and crunching rhythms will all intertwine, rearranged through the interactivity of every viewer.

 Aaron Betsky, curator of art, design and digital projects at San Francisco's Museum of Modern Art, already sees this coming. "What interests me," Betsky says, "is the way in which Web sites that are enabled by plug-ins create compositions that continually recombine themselves in time and space." For the next generation of artists, this will all be second nature. Having grown up in a world far less tied to the physical and thoroughly at ease with a sense of hyperlinked transport across the digital landscape, these artists will make multimedia works of seamless complexity. For them, all this talk of the nonlinear will seem quaint or even unrecognizable. And not for the artists alone. Designers working on the Web can already look at the seemingly strange artworks online and find in these radical renovations of the interface an intimation of what lies ahead. Their practice, too, will change as they create far more immersive experiences in linking information environments. In the meantime, the denizens of the Net keep leaping, making their tiny incremental adjustments from one expression, one experiment to the next; questioning, almost certain, almost blind; making something based in the past but also new, crude as it still is: an infant art.

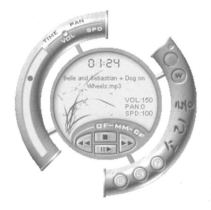

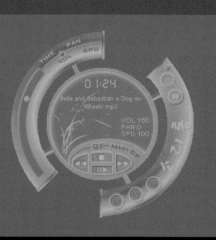

>

FACELESS

INTERFACE:
TRANSPARENT DESIGN AND
THE EVOLUTION OF
INTERNET RADIO

TEXT: CARL STEADMAN

It's a big lie. There's no such thing as "interactive" media. In truth, *all* media is inherently interactive.[1] The key to a truly new media is not interactivity, but transparency, achieved through designing an interface that appears immediately obvious to its users.

The transparent interface so well integrates with the underlying technology that users take their own interaction with it for granted. Because transparent interfaces don't call attention to themselves, it's often difficult to locate the best examples to most profitably scrutinize. Gaining insights from the design solutions found within an emerging technology is one way of circumventing this process of naturalization; not every product in the category has yet

[1]Hypertext, for example, paraded now for years as a new kind of linguistic syntax, has always existed as footnotes, literary allusions, and associations between texts formed in the reader's mind. All the Web does is articulate the associations between media in a concrete visual code. The links between texts become quite literal.

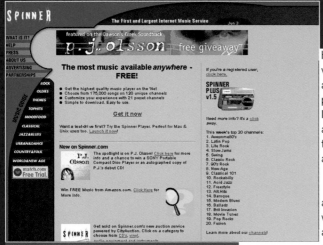

Although Spinner offers some interactive features, like allowing users to rank favorite tracks, it doesn't fundamentally alter the broadcast experience.

had time to adopt those innovations that will soon become convention. These insights can then be generalized, as in the case of audio on the Web, which highlights such trends as automatic personalization and plug-in interface architectures. Where Internet radio and streaming audio may at first seem like obscure and specialized areas of design, the developments we observe in this space will ultimately affect everyone on the Web, designers and users alike.

radical RADIO

So why Internet radio? There already exists a high-quality, high-bandwidth solution with a wide variety of programming options and unlimited free access, available at Radio Shack for $7.95. It's called FM radio. What differentiates the Internet application? One of the more popular Internet radio players, Spinner, begs that very question. Take away the "Internet" and all you're left with is radio. Although Spinner has dozens of station presets, a search interface, and areas for displaying artist and track information, its audio controls are exactly what you'd expect from a radio, Internet or otherwise: a slider that controls volume, and a stop (volume off) button. Spinner does move past analog radio by providing its users with a "Buy this CD" button and a "Songpad," which allows users to "bookmark great tracks to save and buy." Spinner's claim it's "using the Internet to change how people listen to music," however, is probably overstating matters. Spinner does make a token effort towards interactivity: It allows users to rank songs on a scale from one to ten. But the "interactivity" stops there: Spinner doesn't use that data to change the music you're currently listening to; it doesn't even tell you how other users are ranking the same song. Rather, the data is stored, in hopes your vote will influence future playlists.

INTERACTIVE broadcast

So what does real Internet radio look like, one that takes advantage of the unique characteristics of a two-way medium, while preserving the broadcast experience enough to still be called radio? Imagine Radio comes close. While the Imagine Radio technology was recently acquired by Viacom and continues to evolve, the original Imagine Radio interface had already radically altered the listening experience. The design was deceptively simple: a row of station preset buttons, a section for display of sound clip info, a play/pause button, and, most significantly, a fast-forward button. This button, indexed to skip over the current selection, advanced you to the next song in the broadcast. The end result was a "Beavis & Butthead" approach to

media: the ability to say, with the click of a button, "This sucks! Change it! Change it!" At Imagine Radio, every broadcast suddenly became your own personal "Gong Show."

Arguably, radio always had such a feature. It's known as the tuner knob. If you don't like what's playing, you spin the dial and find something else. What Imagine Radio succeeded in doing, then, wasn't providing a new feature so much as a new interface to what we've always taken for granted. In the process, Imagine questioned traditional radio programming by enabling listeners to directly manipulate broadcasts. Imagine Radio has effectively called for a new category of personalized broadcasting.

What was so revolutionary about Imagine's interface was that it was so transparent. There was nothing that called particular attention to the fact that two small design elements, a couple of triangles pointing to the right, were going to change the way we listen to the radio. After all, you can find the same triangles on any CD or tape player. But, through borrowing an interface convention common to any player of audio recordings and applying it to a broadcast environment, Imagine Radio delivered a personalized experience in a

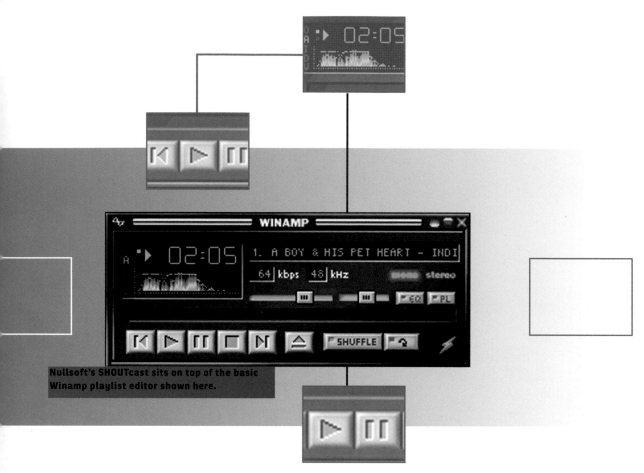

Nullsoft's SHOUTcast sits on top of the basic Winamp playlist editor shown here.

medium whose fundamental mode of consumption has always been passive.

PERSONALIZATION
The temptation, of course, is for those on the product design team to produce a fully "interactive" and "personalized" net radio. On Imagine Radio's Web site, the feature that's most touted is the user's ability to build a personalized radio station. Select that option, and you're asked to rank hundreds of musicians on a sliding scale. It's akin to being required to fill out a ten-page questionnaire before you're able to switch on your stereo. A more elegant user interface might have resulted from the more immediate and transparent approach: the service could simply track the songs and artists that an individual listener fast-forwards past, and play them less often. Over time, Imagine Radio could learn enough about a user to provide a tailored listening experience without any additional interface elements.

Interestingly, you don't even have to personalize your net radio to listen to personalized broadcasts. Imagine publishes all its users' customized radio stations, allowing anyone to listen to anyone else's personalized broadcast. But Imagine Radio's limitations don't quite make this the equivalent of that 5-watt pirate radio station that you've been thinking of building: Imagine only allows its users to specify whether or not they like the artists that the site lists. Users can't specify actual tracks, so there's no way to share that rare bootleg with your growing fanbase. More importantly, Imagine's playlist is generated randomly: It's hard to play DJ when you don't know what track you're spinning next.

MP3 and
ACTIVE LISTENING
Nullsoft's SHOUTcast bridges this gap between broadcast and recorded audio. SHOUTcast is a distributed streaming audio system. What this means is that more or less anyone with a computer and a modem can broadcast audio. SHOUTcast sits on top of Winamp, Nullsoft's popular MP3 player. (MP3 is an audio file format that can store near-CD-quality sound in relatively small, highly compressed files,

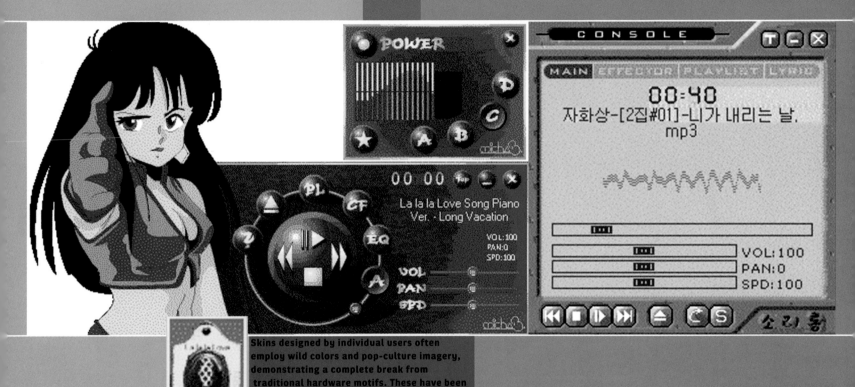

Skins designed by individual users often employ wild colors and pop-culture imagery, demonstrating a complete break from traditional hardware motifs. These have been designed for the Soritong MP3 Player.

making it ideal for Internet distribution.) Users play songs through their Winamp player and relay them via SHOUTcast, to which other users can then connect and listen to the "microcast," as Nullsoft terms it.

What pulls this all together from an interface perspective is the playlist. In Winamp, the playlist is a resizable window into which users can drag and drop MP3 files from their local file system. Though Winamp's playlist editor has little more functionality than Windows Explorer or the Macintosh's desktop file folders, the playlist's ability to structure the listening experience is significant. Where once most people would have listened to albums, the playlist editor allows users to arrange and organize music from their perspective. It's different from building a collection of singles; the playlist focuses your attention on how one song relates to another. While this is nothing new to anyone who's ever given or received a mix tape, it makes music a more active experience. The assemblage of tracks becomes an open challenge to actively craft a greater meaning from many disparate elements. The playlist becomes a kind of information design where the data is mostly audio, the user the designer.

For the casual listener who hasn't invested a lot of time downloading MP3 files or editing playlists, the payoff is in the instant customization available when playlists are exchanged. Via SHOUTcast, the highly motivated can share their expertise while less ensconced users can still enjoy the largely passive experience that is radio. The playlist, then, is both the ultimate form of personalization and the public manifestation of what was previously a private experience.

The Sonique MP3 player (opposite page) also supports skins, an example of which is shown here.

> www.sonique.com
> www.sorinara.com/soritong/english/

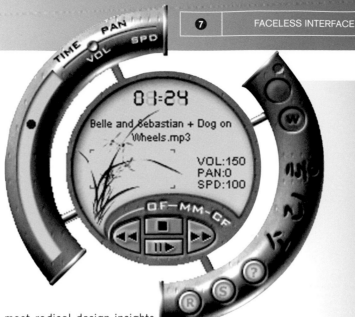

SKINS

Many of the most radical design insights that have manifested themselves within the Internet space exploit this tension between public and private, between widespread distribution and individual customization. Take the concept of "skins," a plug-in architecture for customizing a software interface along the lines of desktop themes in the Mac OS and Windows. First introduced by Winamp, skins allow MP3 players to veer sharply from the clichés rampant in audio hardware (clichés that are often nonsensically carried over to their software analogs). In audio components, it seems, black means high tech, silver means solid state, yellow means waterproof, woodgrain means you picked it up at Goodwill, and anything else means It's My First Sony. With the software-based Winamp, on the other hand, you can choose from over 2000 user-contributed interfaces, from the futuristic to an antiqued woodgrain look. Other MP3 players have taken the concept even further, allowing skin designers complete control over the end-user interface, from the appearance and positioning of buttons to whether or not a volume control can be turned all the way up to 11.

The idea of a plug-in interface architecture, it turns out, was bottom-up, like so many things on the net. Winamp's most fervent users began distributing hacked versions of the player, incorporating their own interfaces with a tool developed by an independent programmer for extracting and replacing the MP3 player's graphics. "For a moment we were disconcerted," says Nullsoft's Robert Lord. "However, we realized that opening up Winamp to custom interfaces would free an enormous amount of caged creativity from users." Support of skins is now a standard feature on most MP3 players.

intuitive INTERFACE

This isn't just about appearances: Sonique, an MP3 player developed in Montana, sports radically stylized curves; an MP3 player called Soritong looks like a space station. But the ability to stand out in a crowd has also spawned many innovative improvements to the user experience: in Sonique, users can switch between remarkably distinct interface layouts, depending upon the amount of screen real estate available; in Soritong, a single slider can be toggled to adjust volume, balance, and go directly to any portion of the song. As Ian Lyman, the principal designer behind Sonique, puts it: "Our goal was to create a 'proof of concept' that used an interface that was functional and intuitive but also radically different from standard Windows applications."

As with any new media, the first instinct is to replicate established conventions, whether or not they may be appropriate. Too many designers of audio software have relied on a literal translation of real-world sound equipment to the computer screen. CD-player applications are made to look just like real CD players, down to LCD displays rendered on a high-resolution monitor. Until the advent of MP3, the advance of consumer audio interfaces hadn't moved very far beyond the limitations of the hardware designs that were their original models.

These innovations in digital audio interface have begun to migrate to other applications: in Web browsers, for example, personalization has moved beyond bookmarks to include look and feel. NeoPlanet, by the company of the same name, is a Web browser built on top of Microsoft Internet Explorer that supports "schemes," plug-ins which allow users to customize the browser's appearance. While NeoPlanet's schemes are rudimentary compared to the truly malleable nature of some MP3 applications (for example, you can't change the location of buttons or other components), it does allow a heretofore-unknown level of control over the interface.

Within the audio realm itself, we're likely to continue to see new developments in interface design, if only because audio remains a unique application, less entrenched in the desktop metaphors of most document-based programs. And in audio and elsewhere, there are yet more opportunities to break the existing conventions of interface design: The uncoupling of interface from the underlying software's functionality in MP3 players and other software encourages a whole new generation of designers who no longer need to be part of a larger development team in order to share their insights into user interface. The era of true mass personalization, promised so long ago, is upon us.

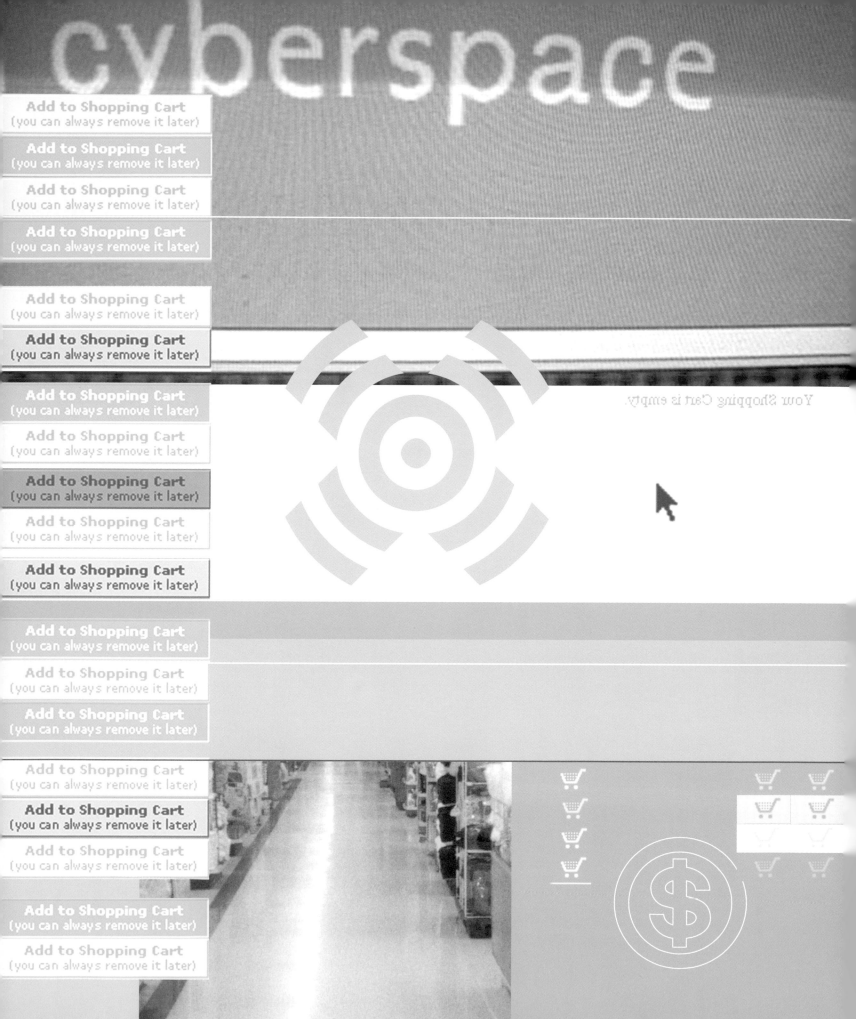

BOOKS | MUSIC | VIDEO | GIFTS | AUCTIONS

Tangerine

Lime

Strawberry

Your Shopping Cart is empty.

>

'ATTENTION INTERNET SHOPPERS':

E-COMMERCE AND THE STRUCTURE OF THE STORE IN CYBERSPACE

TEXT: STEVE BODOW

Apple makes the perfect product (high-tech, high-ticket, handsome) for selling online. And the company's easily recognizable signature Garamond typeface is all the brand-identity reinforcement its Web pages need.

The sheer expense of a computer helps, too; because the shoppers at store.apple.com are making an investment, they are willing to spend a bit of time at the site, so images can be a bit bigger and more eye-catching than one might normally see on the Web. Perhaps the company's biggest advantage is the very narrowness of its product line. With so few choices, navigation can be kept elegantly simple. All electronic merchants—and the designers who work for them—should have it this easy. The Apple

The Apple Store

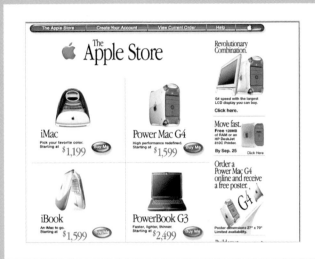

The clean, "well-lighted" homepage at
The Apple Store.

Lime **Strawberry**

Blueberry

In this detail from The Apple Store, a row of
cute, fruit-flavored iMacs tempts consumers
to "select a color" with a click.

Store is the proverbial clean, well-lighted place. Except it's not a place at all.

With e-commerce out of its infancy, a related design specialization is emerging. Designing for e-commerce means devising graphical "selling systems" that, combined with a little Web technology, successfully part people from their money. A glance at Amazon.com or any other sales-oriented site makes it quickly clear that this isn't just brand-identity work with a fuzzy promotional agenda. This is selling. Interface designers have been pushed to retailing's front lines.

space VS. CYBERSPACE

"Selling systems" have existed in the real world for many years, of course: They're known as "stores." Retail architects work to create environments that encourage, not just spending, but also a desire to explore, return, and spend more. Color, lighting, floorplan, display heights, signage—the tools available to interior architects for shaping the perception of space—all come into play in store design, where they give order to what would otherwise be a fluorescently-lit, concrete-floored warehouse of boxed-up stuff. E-commerce designers must similarly organize a huge variety of goods into some comprehensible and appealing order, but instead of having a shop floor to work with, they have to fit it all into a few square inches.

In terms of scale, the task of an e-commerce designer is somewhat akin to traditional page layout, where precious real estate is measured in pixels instead of square feet. But functionally, e-commerce sites work more like architecture. Space—or, more accurately, some metaphorical notion of space—is the central concern. "You have to

> www.store.apple.com
> www.amazon.com

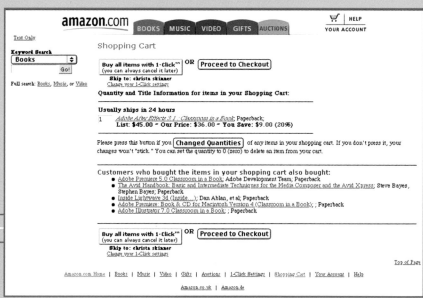

The shopping cart at Amazon.com may not be beautiful, but it's always easy to get to.

understand what the spaces in a store mean, not what they look like," says Brian Jensen, a senior "information architect" (note the title, an increasingly common one) at Organic's San Francisco office. "You replicate the meanings online, not the spaces."

the APPEAL OF ADJACENCY

Interestingly, e-commerce has come along at a time when traditional retailing is itself transforming. Successful retailers like Barnes & Noble and Restoration Hardware have lately taken to the idea that products are used in social contexts, and that displaying them in such contexts helps consumers to better understand the product—not its functionality so much as its potential in their lives. Thus, we see books sold in places replete with comfy chairs and desk lamps, and by the same token, comfy chairs sold in places where books and magazines are strewn about as props. Depending on how it's showcased, a simple cotton bath towel could be a messenger of good economic value, urbane sophistication, international consciousness, or

nostalgia for any given decade in the 20th century. The art of putting certain things next to certain other things—call it the art of adjacency—creates context. Any spatial juxtaposition of products implies a relationship between them; several juxtapositions artfully chosen, a gestalt.

hyperlinks AND CYBERSTRUCTURES

Despite how far contemporary lifestyle merchandising has gone in reorienting ideas of product categorization and order, it's the Web—specifically its defining bit of grammar, the hyperlink—that utterly scrambles our notion of what it means for one thing to be "next to" another. A unique form of cyberjuxtaposition, the link poses an adjacency, an association, a relationship, of a purely mental kind.[1] For designers, this creates a tremendous opportunity to reshape how things are

[1] Since its birth, interactive design has been hailed as a chance to make information conform more closely to the mind's own structure. The field's godfather, Vannevar Bush, outlined his idea for a imagined device he called a Memex in the 1940s. The Memex was essentially a machine for organizing files and information through a network of mental associations, or links. It would record whatever links its user wanted; some might follow conventional subject categories or alphabetical order, while other links might be more idiosyncratic—leading, say, from Bush's file on a prep school friend to the file on the auto mechanic whom that friend recommended. Such a system would be less rationally codified than a strict filing-cabinet or Dewey decimal system, but also perhaps more cognitively or emotionally resonant. Emotional resonance is of course the retailer's Grail—pursuing it by attaching novel types of cultural and "lifestyle" associations to consumer goods is precisely what most modern-day advertising attempts to do.

> www.restorationhardware.com
> www.bn.com

The comfortable surroundings and eye-catching displays found in stores such as Barnes & Noble and Restoration Hardware are replicated virtually on successful e-commerce sites.

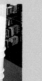

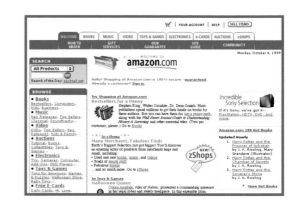

The Apple homepage highlights the sleek lines of its featured product with a focused layout and catchy copy.

The link-laden homepage of Amazon.com offers consumers personalized options without forcing information on them.

sold, with greater flexibility than any brick-and-mortar architect could hope for. Given the Web's total lack of actual spatial order, defining an electronic store's adjacencies—giving context to goods and services in what could otherwise be a formless sea of information—is the e-commerce designer's main task.

THE AMAZON EXAMPLE

Although its visually cluttered site wins as much scorn as praise from digital design professionals—and although the company is a good deal more celebrated for its inflatable stock price than its esthetic sense—Amazon.com is emblematic of the new design discipline. Unlike The Apple Store, Amazon is set up to encourage heavy-duty browsing—thus the link-laden pages, each bit of blue text serving as both promotional copy and signage program. The site gives customers an infinity of choices, creating the feeling that there's always more to see, and that return visits will always be rewarded. That's Amazon's business—customers making lots of little buys over the course of several visits a year. Apple, on the other hand, might hope to sell someone a computer three times in a decade. Different customers, different shopping experiences, different design strategies.

At Amazon, graphical adjacencies represent a remarkably complex system of meanings, and, therefore, of cues to guide you to more product. The basic design unit at Amazon is the book page—like the one illustrated here, for George Lois's *Covering the Sixties*. The page's central element is a photo of the cover and the basic information about the book—author, publish-

er, and so on. Immediately to the right is the most important link—the one that puts the book in your "shopping cart." You can even "one-click order" if you've visited Amazon before, zipping straight from the bookshelf to checkout. At Amazon, you're never more than a step away from the cash register.

Notice, then, that just above the book cover, George Lois's name is highlighted. It's a link that will take you to the "section" of the store where all of this author's books are, regardless of whether they're fiction, non-fiction, or even children's books. Some readers are loyal to a given author, and for them this link—this architectural gesture that provides them with a room of their own—is immensely valuable. Just below the book information, the page's main column runs a listed of "suggested" titles (the subject of some controversy in early 1999, when it was revealed that Amazon had, for a brief time, been selling the "suggested" billing to publishers), as well as a separate list of purchases made by Amazon customers who also bought the Lois book. Further down is a list of topics related to the book, where a shopper can look for similar books on the subject. Each item provides a link to its own "section" within Amazon's art and music department: There's Lois himself, magazine covers, graphic design, or, somewhat more broadly, "1945–", and even "civilization." This is simple, mechanical

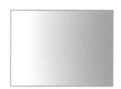

The Wal-Mart Web site struggles with replicating the bounty of its real-life superstores on a 13-inch computer screen. Its search engine lacks the visual cues and cross-merchandising found in other e-commerce environments.

(and occasionally clumsy) database stuff—but also a crucial design choice. Reviews, both by professional writers and other Amazon customers, are available, too. Think of each link as leading to a room in the Amazon building and you begin to see a very complicated architectural construction. How the rooms are arrayed off the main chamber will go a long way in determining not only how many times each room is visited, but also how rich an experience shoppers will perceive themselves as having.

on THE FLOOR TO ONLINE

There's no better example of a successful real-world retail-design approach translating badly to the Web than Wal-Mart. America loves Wal-Mart, arguably history's most successful retailer. Its superstores dominate the shopping scene in whatever towns it chooses to open them, and when you walk into one, it's easy to understand why. There, in the sprawling aisles, you can see the limitless cornucopia of goods available to you, tangibly feel the vastness of it all, appreciate (if you're in a philosophical

Back Forward

"associated links"

state of mind) what a rare, fortunate time and place you are lucky enough to inhabit. The whole world of consumable goods seems laid before you—all at low, low prices. Wal-Mart is pleasurably overwhelming.

So why does Wal-mart.com sputter? The site offers thousands of items, from microwaves to polar fleece. You can read through lists of product categories and subcategories, hundreds of names at a time, until you find the item you want. But within the lists there are few visual cues to humanize the experience. To be fair, Wal-mart.com's online challenge is a tough one. The expansive physical space that is one of its most valuable real-world merchandising assets—the joyous sense of plentitude that virtually defines the company—is gone. "It's harder to elegantly direct people online," notes Organic's Jensen. "While your shelf space is boundless, your perceptible space is extremely limited." Indeed, visually, the Wal-Mart experience has always been measured in acres. Hop online and suddenly the gigantic chain is trying to sell you through your 13-inch computer screen. Wal-mart.com

doesn't seem like The Whole World; it just seems like Some Stuff. There's no cross-merchandising, none of the things that makes shopping fun—no adjacencies.

community AND CULTURE

As ground-zero for serious Web retailing, Amazon.com's choice of what products to sell is telling. Social contextualizing functions particularly well in selling cultural products, which have natural links (e.g., what other music, literature, etc., influenced or was influenced by the art in question) to other pieces of culture. That's why Amazon succeeded as quickly as it did. Other retailers have been slow to catch on to the power of associative links—the medium's message. "You have to find a way to put people back into the process," says frogdesign creative director Lowell Goss, "to make someone relate to the sweater or whatever, not in exactly the same way, but to the same extent they would in a store."

BOOK ⌇ WAVE

Bookwave is a whole new way to experience a book online, a completely self-
contained package of information that's like holding a book in your hands -- but better.
Our first Bookwave features are from HarperEdge, where culture and technology meet.

Bookwave requires Shockwave.

david shenk

**DATA
SMOG**

SURVIVING
the information glut

ecstasy club

what
WILL
be.

DERTOUZOS

INTERFACE CULTURE

HOW NEW TECHNOLOGY
TRANSFORMS THE
WAY WE CREATE AND
COMMUNICATE.

STEVEN JOHNSON

Data Smog
(Paperback)
by David Shenk

Ecstasy Club
(Paperback)
by Douglas Rushkoff

What Will Be
(Paperback)
by Michael Dertouzos

Interface Culture
(Paperback)
by Steven Johnson

GET
SHOCKWAVE

⚏ HarperCollins

**Bookwave.com contains multi-media
information about book titles in an effort
to capture the immediate experience of
browsing in a store.**

bookwave AND INTERNET "OBJECTS"

Oven Digital's Bookwave project for publishing giant HarperCollins attempts to enrich the book-buying experience in just this way. "Shopping is a cultural experience," suggests Oven principal Miles McManus. "People want shopping as entertainment." Like real-space retailers such as Restoration Hardware, e-commerce companies must eventually appreciate that, as Oven creative director Hal Siegel puts it, "It's not just the CD that I want to buy, but how I want to buy it."

Bookwave is essentially a small computer application—an "object" in coder jargon—that contains multimedia information about a given book title. "When I go to a bookstore maybe I have a couple of titles in mind, but I enjoy serendipitous browsing," says McManus. "Those displays at the end of each aisle, where the books are face-out or in stacks, make it easy to bump into a new or topical idea." Oven's idea was somewhere between devising a way for publishers to install the equivalent of these in-store displays at e-commerce sites and recreating the experience of pulling a book from a store shelf and reading the jacket copy, looking at the artwork, or skimming an excerpt—many of the things one might do before deciding to actually buy. Some of these infobits are sporadically available at Amazon or its

Presenting a stylish image and plethora of choices, Kenneth Cole's e-commerce site offers hundreds of products, some of which are only available online.

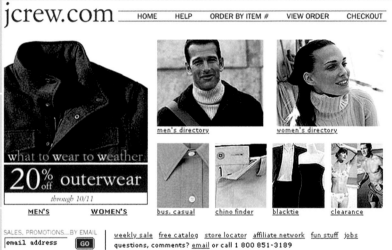

The J.Crew Web site rotates featured items on its homepage. Soon, we may see similar impulse offers in the "check-out line."

cousins, but when they're only text, they're a bit bloodless. Bookwave and ideas like it could make browsing online a bit more pleasurable.

impulse OFFERS
Other lessons and devices from real-world store design are finding their way online. The next big wave to hit may well be impulse-buy goodies. Sites from firms like Organic, Agency.com and others will soon be flashing inexpensive last-minute ideas like candy, novelties, or clearance items before e-shoppers' eyes during check-out; here, the relevant adjacency is the one between a product and your wallet, which at that point in the process is essentially out and wide open. Sophisticated versions of these point-of-purchase temptation engines will, based on who you are and what you're already buying, intelligently choose which doodads to show you.

What's it all mean for designers? With measurable dollars at stake, design choices can't be frivolous—the heretofore slippery question of whether a given design "works" or not is too easily answered on e-commerce sites for that. In this sense, e-commerce is a call-back to basics: layout, structure, and clarity. The art of the matter is in providing context—a sense of quasi-spatial, conceptual, and even emotional connections with whatever's being sold. It's a tall order. The up side, though, is that the Web is an incredibly flexible medium, inviting ever-more creative solutions even as it presents problems of ever-greater complexity.

Jenny Spoinkin stole your boyfriend in ninth grade.

She married him.

Chuck Swank 196[3]

Chuck Swank 199

You searched for diaper

Search Again

02

JERRY

YOU

>

IT WAS SUPPOSED TO BE AN AD BANNER, BUT, WELL LET'S JUST SAY

A BETTER BANNER:
WEB ADVERTISING AND
SPONSORED INTERACTION

TEXT: ANDREA MOED

Someday, maybe soon, people are going to get nostalgic for the Internet of the 1990s. In the full-screen, full-motion digital world to come, they will crave flash-backs to the days of limited bandwidth, static interfaces, 216 "safe" colors, and a gawky young medium redolent with the promise of future ubiquity.

That's when we'll recall "classic" banner advertising. At the top of every retro-design HTML page ("The Web used to come in 'pages,' you know...") will be one of those skinny rectangles trotting out its miniature message. Frame One: WIN THIS CAR!!! Frame Two: Click Here!

Online advertising is perhaps the most conspicuous reminder of the Web's lingering immaturity, if only because its decades-old counterparts in TV, film, and print are so diabolically sophisticated. In the broadband world, we are surrounded by a circus of campaigns: basketball gods, choosy moms, and manic bunnies, all extravagant-

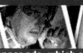

LYCOS PeopleFind *"Hey Remember Me?"*
Find People, Phone Numbers, Email Addresses And More

He still owes you 50 bucks.

She never returned your sweater.

Jenny Spoinkin stole your boyfriend in ninth grade.
Chuck Swankbarrel 1963

She married him.
Chuck Swankbarrel 1997

These catty banner ads, which suggest using Lycos's PeopleFind to track down long-lost acquaintances, employ a textual one-two punch.

ly produced and calculated to transfix us. Meanwhile, on the Web, we see Fortune 500 corporations paying big money for a form of advertising with all the smoothness and suavity of a line of Burma Shave signs along a highway.

banner BAGGAGE

Introduced in 1994, the banner ad is an illustration of Marshall McLuhan's theory that every new medium arrives bearing the baggage of the media that came before. Like print advertising, the format was designed to be modular: produce the ad once, use it everywhere. It has an interstitial place in the layout: at the top of the page, where it is likely to be read after the site identity and before the content. As for its design, a few rules of thumb evolved quickly. Because Web pages typically have dark text on a light background, banners usually come in saturated hues, with reversed-out type to contrast with the page. Most contain one or two animating elements to produce eye-catching motion without a long download time. The resulting ads bring a little bit of Times Square to every Web page they adorn. The colors vibrate, the slogans flash, and the words "click here" invite the reader to go straight to the advertiser's site. As with most ambient noise, people tend to ignore them.

By 1996, the Web's vaunted customer tracking capacity showed users clicking on banners an average of one percent of the time—a poor performance even by direct marketing standards. It wasn't long before the phrase "beyond the banner" became an industry battle cry. Nonetheless, online ad agencies defended the format and continue to defend it, even as they explore higher-tech options. "Banners are here to

> www.whowhere.lycos.com
> www.poppe.com
> www.parentsoup.com
> www.ivillage.com

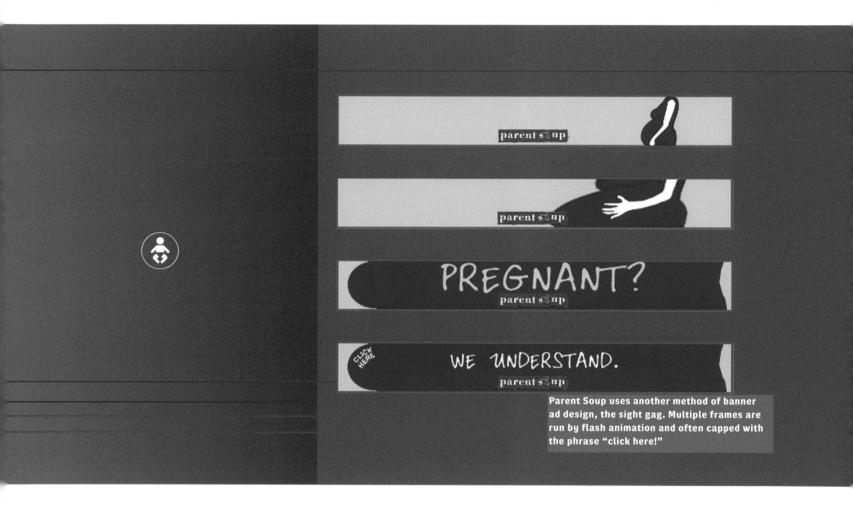

Parent Soup uses another method of banner ad design, the sight gag. Multiple frames are run by flash animation and often capped with the phrase "click here!"

stay," says Kyle Shannon, creative director of Agency.com. "We could be doing really great killer banners if we put some more creative minds to work on it." Co-chief creative officer Matt Freeman of DDB Digital maintains that even the simplest and least memory-intensive designs can attract clicks. "You know what? You could do a great ad, black letters on a white background, maybe three words, and it could work."

Every so often, an ad comes along that proves banner advocates right, demonstrating the unfailing adaptability of the best Web designers. Adopting minimalism as a creed, these creatives pare each banner down to its thematic core. The most popular approach is the textual one-two punch, demonstrated by a series of blunt Lycos banners by Modem Media.Poppe Tyson that suggest using Lycos's PeopleFind to track down the jerks who tormented you in high school. A banner promoting the site Parent Soup, part of the iVillage Network, shows an alternative strategy, the elegant sight gag. A rough five-frame animation shows a woman's belly expanding beyond the banner's little frame. "Pregnant?" asks the copy. "We understand."

In this and other respects, naive banner design is growing ever-more refined, much the way the design of posters, magazine ads, and TV commercials has done. But this creative refinement has little to do with why Web shops continue to stand behind banners, or why clients keep buying them. The more significant developments have occurred on the back end, in the way banners are distributed among host sites and targeted at potential customers. Software has rationalized the marketplace, following a mid-'90s boom in companies and programs that keep numerical tabs on Web visitation and gather information about the visitors. Webmasters are getting increasingly good at discovering everything about an incoming visitor—from her age and location to the Web site she visited just before—and responding with the most demographically favorable ad.

portals and
KEYWORDS
The Web's most popular sites, the directories and search engines, are on the cusp of the targeted ad-placement trend. Known as "portals" in industry jargon, Yahoo, AltaVista, and their many competitors are where people go to ask the Internet a question. It is the great hope of the sponsors of these sites to answer that question with an ad. Media buyers place their ads on search engines by purchasing key-

> www.excite.com
> www.yahoo.com
> www.altavista.com

Media buyers purchase keywords at portal sites like Excite and Yahoo! This means that whenever a user enters a keyword, such as "diaper," related products and banner ads will appear on the search-results page.

words, meaning that whenever you type, say, "diaper" into the search form, you'll always see a banner ad for a particular online baby products store.

This example begs the question of what is more important, the "eye appeal" of the banner or the software that causes it to appear in some cases and not others. It could be argued that a banner on Yahoo isn't really an ad unto itself anymore; it's just one small component of the networked, reactive advertisement that constitutes the whole search engine. Real-time targeting makes banners critically different from posters, magazine spreads, and even TV ads. It's the end of advertising as a graphically discreet phenomenon.

creating VALUE So what are Web ads becoming instead? "Value," says Joel Hladecek. "Advertising communicates value, but interactive advertising is value. It's entirely about the user and what is perceived as being valuable to them." Hladecek is chief creative director of the San Francisco-based Web shop Red Sky Interactive. RSI is known for its work with advertising vanguardists like Nike and Absolut Vodka—businesses more celebrated for the media they produce than for their tangible products. Among the creatives at Red Sky and other forward-thinking Web shops, there is a palpable veneration for companies like these, which built brands up from obscurity with

advertising that attracts its own audience. Web advertisers know this challenge well: their work must attract an audience or it might as well not exist. When Web creatives think about how to do this, "value" is a concept that comes up frequently. But as they take pains to point out, their idea of value isn't just mounting a buzzworthy spectacle. Spectacular ads, after all, are an old media thing, most suited to year-end issues of mass-market magazines, or televisual events like the Academy Awards or the Superbowl. The familiar Bud Bowl TV ads are a perfect example: a big-budget production that is actively anticipated and talked about by Superbowl audiences in need of comic relief during the big game. When the Web shop DDB Digital took the campaign online in the form of Budbowl.com, they could have reprised the TV experience in streaming video. Instead, they created something analogous to "destination" stadiums in the real world, where watching the game is only one of many amusements. The unique attractions at Budbowl.com, which is sponsored by Anheuser Busch, are twitch games in which users can

> www.budweiser.com
> www.ddbdigital.com

Like a theme park, Budbowl.com provides an assortment of diversions, which appear in rapidly proliferating pop-up windows as users navigate the site. High-bandwidth users can simultaneously watch the Bud Bowl and play a video game based on it; clicking on the passing blimp takes them to another part of the site.

maneuver the famous football-playing beer bottles through various plays, with Web TVs awarded to the high-scorers; an animated "host" that answers typed-in questions; and e-postcards that users can send their friends "from" the Bud Bowl.

The "value" of the Bud Bowl site has less to do with beer than with Web culture. The feature set of this and other DDB Digital sites is based on careful observation of what the audience likes to do online. Co-chief creative officer John Young says, "You don't want to put them in some alien world, you want to come to them. We've watched guys trading software, interacting in chat rooms, dressing up their pages in Tripod, using Instant Message or ICQ. It's fascinating how it's changing culture." Budbowl.com takes favorite applications of football fans, such as email and networked games, and wraps advertising around them. The result, says Freeman, is that people (at least those over the age of 21) are "interacting with the brand."

SPONSORED **INTERACTIONS** Advertising sites increasingly offer services like postcards, games, and free screen savers that used to be available mainly through personal, academic, or less commercial sites. At the same time, expanding sponsorship programs have enticed previously less-commercial sites and services to carry advertising. These developments bring to mind the critic Leslie Savan's phrase "the

Sponsored Life," coined to describe the ubiquity of promotional messages in the broad-band media environment. Today, in a networked world where one can find a recipe, a job, a mate, a new favorite band courtesy of a sponsor, or become the conveyor of an ad by sending email or building a homepage, Savan's phrase is all the more apt. Advertisers thrive online by turning our interactions with computers, and with other people through networks, into sponsored interactions.

"TRUE USE" In a few cases, advertisers don't just appropriate existing Internet communication models; they commission new ones. RSI's much-publicized Absolut DJ site is such a design. The site, dedicated to the newly revived and trendy DJ movement, features a mixing program for novices called Visual Music. Created in Shockwave, Visual Music lets players make a DJ-style mix using a gameboard-like interface. The player places icons on the board representing different sound samples. As two "play heads" move around the board, they play the selected sounds, along with animations inspired by the sounds. The experience is nothing like using an instrument, but the flick-ering animations do impart a strange beauty to the screen. What makes it all the more engaging is that there is no composition stage followed by playback. The play heads are constantly moving, and it is always possible to add and subtract sounds from the mix. By changing the board over time, the player can perform a literally infinite number of compositions.

The Tlounge site, which targets teenage girls, features articles, medical information, links, and a BBS (Bulletin Board Service), all sponsored by Tampax.

COMPILATION

COLDCUT

ABSOLUT DJ

AN EXPERIMENT IN
CREATING VISUAL MUSIC

v1.0

FAQ

CREDITS

ARCHIVE

HISTORY OF THE DJ MOVEMENT

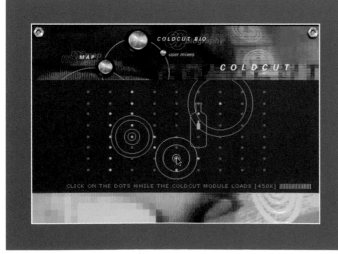

CLICK ON THE DOTS WHILE THE COLDCUT MODULE LOADS [450k]

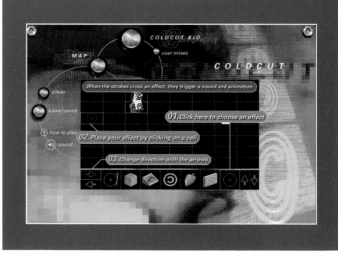

When the strobes cross an effect, they trigger a sound and animation

01. Click here to choose an effect

02. Place your effect by clicking on a cell

03. Change direction with the arrows

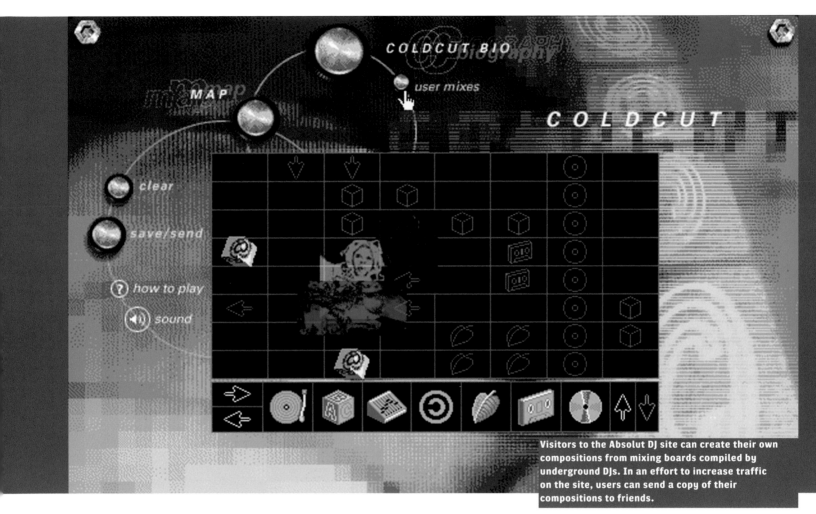

Visitors to the Absolut DJ site can create their own compositions from mixing boards compiled by underground DJs. In an effort to increase traffic on the site, users can send a copy of their compositions to friends.

Absolut DJ is an extension of Chiat/Day's ongoing print campaign for Absolut, which makes strategic use of artists and writers as ad auteurs. The well-known print precedent seems to have inspired RSI to innovate. "Even if [the ad] links to a campaign in another medium, we want to create unique experiences that can only occur in this medium," says RSI senior art director Kirk Gibbons. "We call that 'true use.' If it can happen on TV or in print, we have to keep pushing it." What makes this campaign Webworthy is that it lets users both create and communicate, says Gibbons. Having made their own music mix, they can also send a copy to their friends, who can then go to the site and remix it.

According to Gibbons, Absolut requested the DJ site with a very specific goal in mind: to impress a particular group of influential young urban types that its marketers call "rad grads." It makes sense, then, that the site offers a service that looks strikingly like arts patronage. The Visual Music mixer clearly meets an existing creative desire; it's just too abstract an idea to put across to anyone who isn't already interested. What's surprising is that those who are interested would understand and accept a vodka maker giving them access to the tools of music making. Looking ahead, it seems hard to

The introductory screen on the Absolut DJ site subtly transforms an equalizer display into the shape of an Absolut vodka bottle.

imagine that people who get their culture on the Web will see a distinction between art and commerce.

BRANDED
INTERACTIONS

The strategy behind sites like these is to get users "interacting with the brand" for as long as possible. Executives and Red Sky and DDB Digital point with pride to findings that visitors spend as much as half an hour on their more intensively interactive sites. Hladecek is predictably bullish on this trend. "I think what you'll see more of are advertisements that try to get you to the Web site. Because, ultimately, it's there that a much deeper experience can be had, that a much longer-lasting relationship can be built," he says. In an entertainment market that seems like it can't get any fuller, advertising Web sites may contend for people's attention with television, magazines, and public events.

Obviously, they already compete with one another. Surfing the Web these days, it can sometimes seem as if everything you see represents some extensive demand on your time—even banners. "Rich media" models, powered by Java and Shockwave, have changed the banner's function, allowing users to have extensive "inter-

> www.absolutdj.com
> www.redsky.com

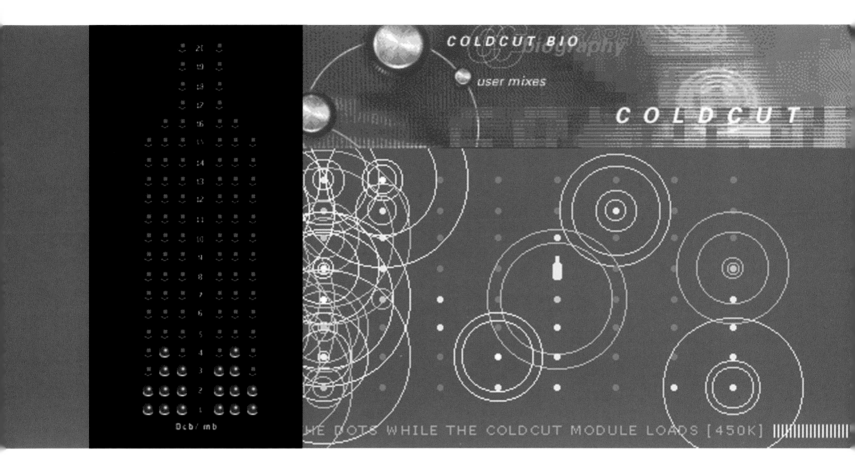

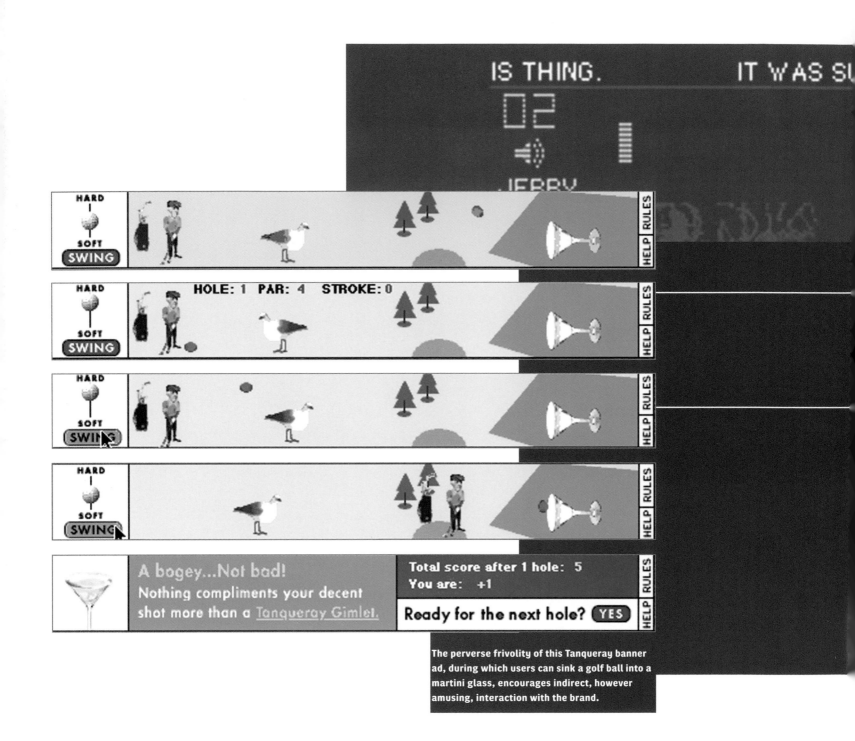

POSED TO BE AN AD BANNER, BUT, WELL LET'S JUST SAY THE COFFEE

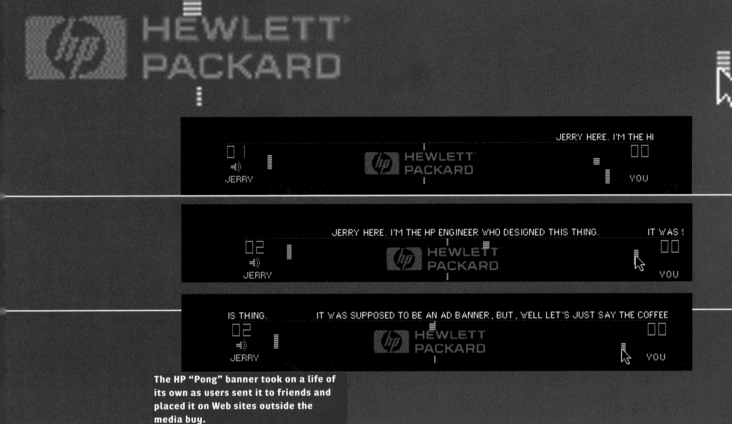

The HP "Pong" banner took on a life of its own as users sent it to friends and placed it on Web sites outside the media buy.

actions with the brand" before even going to a full Web site. By putting a tiny video game inside the frame of the banner, advertisers can get people staring at the top of a page for minutes at a time. It's hard not to admire the perverse frivolity of campaigns like RSI's Pong banner for Hewlett-Packard, and the banner-sized, nine-hole golf game created by iDeutsch for Tanqueray Gin. Still, staring at a few square inches of their seventeen-inch screens and positioning a golf club to hit a little ball into a miniature martini glass, players may wonder exactly what this inter-action is buying the advertiser.

No such doubts seem to abide in the industry. Among advertising profession-als, they're working on the model of relationship marketing: hang around with a brand enough, and you'll inevitably buy in. This leap is assumed to be especially easy on the Web. As Agency.com's Kyle Shannon has noted, "Advertising is the assertion [part of the customer rela-tionship, but on the Web, you can also do provision and consultation." Budweiser sells no beer on Budbowl.com, but it does sell hats and T-shirts. The point is to habituate customers to a steady rhythm of playing, buying, and coming back for more. "It always strikes me as silly when people say it's all content or all transactions," says Freeman. "We're talking about human beings—our lives are not ruled exclusively by transactions or content. You can buy plane tickets online; that doesn't mean you're not also interested in being entertained, communicating with friends, or finding information. There are a lot of different human needs, and the Internet is another way of speaking to them." For some of us, the Internet is post office, coffeehouse, museum, and library. Thanks to interactive advertising, all those places are getting a lot closer to the supermarket. And if the supermarket can exist in a space 468 pixels long by 60 pixels high, so much the better.

YOU

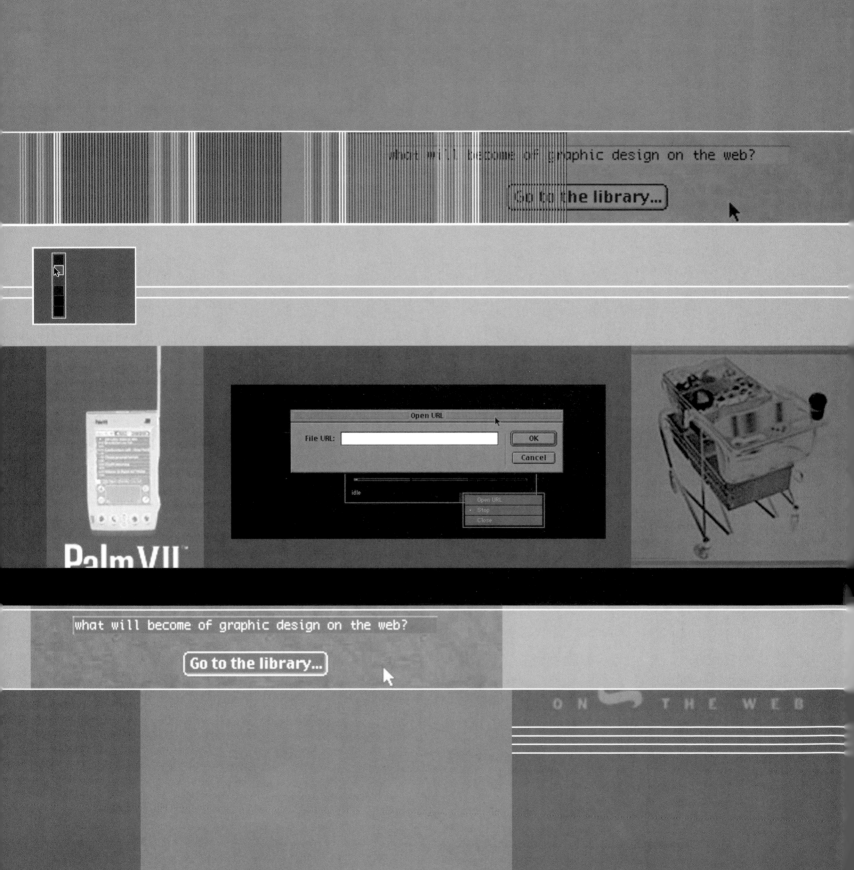

what will become of graphic design on the web?

Go to the library...

Open URL

File URL:

OK

Cancel

idle

Open URL
Stop
Close

PalmVII

what will become of graphic design on the web?

Go to the library...

ON THE WEB

FAT GRAPHICS, > FLIES, AND THE END OF WEB

DESIGN: A POSTSCRIPT

TEXT: PETER HALL

One of the highlights of the Web is the "stichomancy" site, where the dubious practice of seeking inspirational guidance by reading a random passage from a book has been conveniently automated—perhaps for those without access to a bookshelf. The online experience is somewhat lacking, though, since part of the pleasure of stichomancy is in selecting a volume, blowing off the dust (or removing the Post-it notes), and enjoying its weight, smell and texture before embarking on the desired spiritual journey. This involves summoning a troubling question to the forefront of the mind and projecting it over the fanning pages, awaiting the moment, the psychic gap, at which the book will halt and reveal its answer.

Nevertheless, devoid of these material and ritualistic aspects, the stichomancy Web site offers itself as an appropriately digital oracle for digital questions. In 1150 B.C., when the *I Ching* (perhaps the originator of stichomancy) was first written down, those seeking advice were obliged to manipulate 50 yarrow sticks into hexagrams in order to obtain the book's wisdom. Today, they need only type in the question and hit the "return" key.

"What will become of graphic design on the Web?" Responding to this anxious query, the stichomancy site gave forth a couple of enlightening stanzas from Lewis Carroll's poem in *Alice's Adventures in Wonderland*, "'You are old, Father William . . . :

. . . And have grown most uncommonly fat;
Yet you turned a back-somersault in at the door—
Pray, what is the reason of that?'

'In my youth,' said the sage, as he shook his grey locks,
'I kept all my limbs very supple
By the use of this ointment—one shilling the box—
Allow me to sell you a couple?'"

FAT GRAPHICS

As a summary of the status quo, the answer is astoundingly pertinent: Graphics on Web pages have grown uncommonly fat and distractingly agile. Several years after the release of Mosaic, the first major graphic browser for the Internet, we're still waiting for graphics to download. Singing and dancing JavaScript, flash animations, somersaulting GIFs and JPEGs, serv-

er pushes and pulls, and dynamic HTML all seem to be doing their best to make Web sites eye-catching and difficult to escape. Like Father William, Web graphics also seem to be increasingly driven by ruthless commercial motives, preying even on innocent children with their sales tactics, be they peddling ointment or candy. By pacing the user experience so that his or her initial sense of destination is gradually obscured over a course of mouse clicks, design ensures economic viability by sustaining the duration of a "hit" and directing users past as many ads as possible. Unlike television and magazines, which at least try to separate ads from "content," graphic design on the Web shamelessly crosses the line between entertainment and advertising, so that parents find their children transfixed by commercials disguised as puzzles and games. At the General Mills Fruity Obstacle Course, for instance, users play in an onscreen Fruit Roll Ups factory stuffed with sticky product placements.

GUERRILLA Webfare
No wonder they call it the Web. It's surprising users aren't referred to as flies. Luckily for those of us unwittingly mesmerized by the sizzling icons of this gaudy Web Wonderland, a Puritan insurrection is coming in

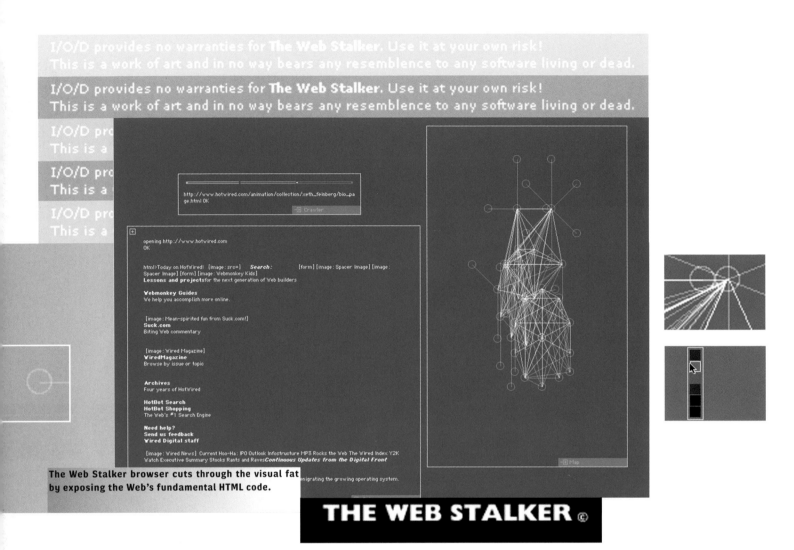

THE WEB STALKER ©

The Web Stalker browser cuts through the visual fat by exposing the Web's fundamental HTML code.

the form of guerrilla browsers. One such device is the British design group I/O/D's Web Stalker. The memory-lite application, which can be squashed onto a floppy disk, is I/O/D's alternative to Navigator and Explorer, which it considers "almost identically pointless and bloated applications weighed down by out-of-date interface metaphors." Web Stalker reduces the World Wide Web, with all its gizmos and sales devices, to white squares and text on a black screen. Using an "extract" command, the user can suck all the text out of a chosen Web site and discard the "design." A map (resembling a diagram of atoms) identifies the available links, enabling users to navigate at their own speed and eliminate pointless click-through time. The Web Stalker philosophy is explained by Simon Pope, one of its creators, in an interview with Geert Lovink: "Commercial interests have tried to exploit the Web by controlling the velocity of browsing," pontificates Pope. "The Stalker subverts this. It confounds the faux melodrama of the clickthrough by automatically making the link for you. Suspense is ridiculed and fluidity is returned to a realm where processes of delay and damming are recognized advertising opportunities." Though in its first incarnation it resembles more an art project, or hacker's toy, than a usable tool, the lean and mean Web Stalker indicates just how utilitarian the Web could be.

> www.backspace.org/iod
> www.expedia.com

Expedia.com is searching for flights. Please wait.

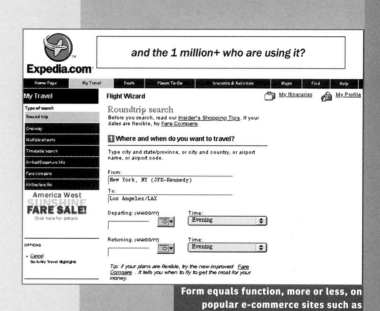

Form equals function, more or less, on popular e-commerce sites such as Expedia.com.

E-COMMERCE AND
VISUAL EFFICIENCY
Currently, online activities can be narrowed down to three types: information-gathering, entertainment-seeking, and shopping. The first two are increasingly cluttered by advertising. Shopping, however, subsidizes itself. As a result, the e-commerce sites like Amazon.com are often strikingly spare, clear, and functional. No need for old, fat, somersaulting graphics here; just point and click, find and spend. Ironically, after all those years when the Internet was supposed to be a liberating public domain for the cross-exchange of information, it comes down to the ingenuousness of e-commerce to make the Web more user-friendly. Finding a cheap airfare has never been simpler: Expedia.com does a better job than most human travel agents. Reading *The New York Times* online everyday is a tedious task, but searching for articles on the *Times*'s archives is the easiest way yet invented to spend $2.50. Many of the leading e-commerce sites began life with bloated pages stuffed with unnecessary graphics. Now they are efficient, functioning machines with occasional moments of elegance.

IDEO's smart shopping cart is one of a plethora of streamlined, wireless products and appliances now in development. These products often deliver information to users on tiny black-and-white screens or liquid crystal displays, leaving little room for graphic eye-candy.

International

IDEO

> www.3com.com
> www.IDEO.com

THE DESKTOP
VANISHES

The writing is on the wall for Father William and his somersaulting graphics, no matter how much ointment they have to sell. Various surveys in late 1998 indicated that people are mostly using the Web as a kind of giant database, not for entertainment, but for extracting information and buying things. The quicker and more efficiently this can be done, the better. When the do-it-all desktop computer finally disappears and the Internet is no longer something you find onscreen, but integrated in the everyday objects around us, fat graphics will be history. The new wireless PalmPilot, for instance, a computer with a screen the size of a tarot card, delivers stock quotes, weather and street directions on demand, but not via a bloated Web browser application. Palm's Internet navigator is a purpose-built applet that expediently logs in and logs out of its destination (for a fee, of course). Eventually, or so we are told, everyday activities like food shopping will be Internet-dependent. First, we tell our Electrolux Screenfridge to add beef sausages to the email shopping list for the weekend. Then, at the supermarket (nobody wants to deprive us of the tactile pleasures of food shopping), we beam the list into our palmtop, or shopping cart-top screens. There are no lines at the supermarket anymore because there are no registers. The IDEO-wired shopping cart has a handheld scanner so that we can check out our own sausages. A security alarm alerts us and the guards that we neglected to scan in that second pack of sausages on the way out of the store. Again, the key to a successful product will be a fast, clear, concise, and navigable interface, rather than a web of distractions.

The Web is a strange beast, since it was invented as a medium to assist the exchange of academic papers, and somehow became a destination. Many designers have learned to decorate the destination, rather than improve the function of the medium. Eventually, the Web along with all its whizzy effects will be superseded by newer and better means of accessing information or purchasing items. Perhaps even the Web's role as an entertainment destination will be hijacked by interactive TV. Designers should therefore be wary of obeying the Web's demands. The last word on this comes by way of a page in Edward R. Tufte's *Visual Explanations* (Graphics Press, 1997), consulted this time without the aid of stichomancy. To illustrate the dangers of being imprisoned by the arbitrary technology of the day, Tufte shows a map of Britain from around 1250, in which the landmass looks as if it has been squashed from the north and south ends. A note on the map from the cartographer, Matthew Paris, explains the distortion: "The whole island should have been longer if only the page had permitted."

contributors >

STEVE BODOW'S writing on technology, media, business, and culture has appeared in *Wired, New York, Details, Slate, Feed, Suck,* and many other publications. He is also co-artistic director of Elevator Repair Service, which *New York* magazine has called "the best experimental theater troupe" in New York City. Bodow has a B.A. in art history from Yale University and an M.A. from New York University's Interactive Telecom Program.

CLIVE BRUTON is a typographic and Web-production consultant, living and working in London, England. He studied typography at the London College of Printing, where he also developed an interest in computer-related design and production issues. After he graduated, just at the time when the Apple Macintosh began the displacement of traditional typesetting and artwork, Bruton became a freelance graphic and type designer, often emphasizing emerging technologies. He has designed typefaces for Reuters' corporate identity and Debenham's stores and has worked on large-scale corporate Web-site design and production for clients including Diageo, Prudential, and Canon.

DARCY DINUCCI has staffed and freelanced as a writer, editor, content provider, content strategist, producer, project manager, creative director, interaction designer, and PRINT magazine's "Design & New Media" columnist. She is currently director of information architecture, director of Web-site planning, director of content architecture, or director of user experience (depending on the staff scenario of the day) at a Bay Area Web start-up. She lives in San Francisco.

PETER HALL is senior writer at I.D. magazine in New York City. He wrote and co-edited *Tibor: Perverse Optimist* (Booth-Clibborn Editions, 1998) and has contributed essays to the upcoming books *Architecture and Film* (Princeton Architectural Press, 2000) and *Sex Appeal* (Allworth, 2000). He is editor of *Sphere* magazine and also writes about design for *The Guardian*, PRINT, *Joe*, and the *AIGA Journal*. His night job is playing bass guitar with a Latin lounge band called the Moonrats.

A senior designer in the new media department of Nuforia, Inc. in New York City, LAUREL JANENSCH is responsible for conceptual development and visual and interface design for clients such as Altoids, Lands' End, and Paine Webber. Previously, she was a senior designer at Avalanche Systems, where she designed and art-directed projects for clients such as *The Wall Street Journal*, The One Club, Bankers Trust, *Parents* magazine, *Encyclopædia Britannica*, and NBC. Janensch also acted as creative strategist at Avalanche, developing and writing strategy documents for companies including Andersen Consulting, Société Générale, and the Hard Rock Cafe. She has traveled extensively throughout India and Southeast Asia researching global Web development and design and taught Web design at the National Institute of Design in Ahmedabad, India.

STEVEN HENRY MADOFF writes about art for *Time* magazine, *The New York Times*, and *Artforum* magazine. He is deputy editor of *Time Digital* magazine, executive editor of *Joe*, Time Inc.'s new culture magazine, and editor of *Joe*'s Web site, joemag.com. He also served as deputy editor of Time Inc. New Media and was responsible for national content for the launch of Time Warner's cable modem service, Road Runner. From 1987 to 1994, Madoff was executive editor of *ARTnews* magazine and he is author of *Pop Art: A Critical History* (University of California Press, 1997). His book of poems, *While We're Here* (Hard Press), was recently published. He has written a number of articles about art and new technology, covering everything from artists to interfaces, collecting to conservation.

more contributors >

JOHN MAEDA is Sony career development professor of media arts and sciences/assistant professor of design and computation at the MIT Media Laboratory in Cambridge, Massachusetts, where he also directs the Aesthetics and Computation Group. After he graduated from MIT and went on to study graphic design in Japan, Maeda began to experiment with ways to bond the simplicity of good graphic design with the complex nature of the computer. Those experiments grew into a series of five books called *Reactive Books* (Digitalogue 1995-97). In spring 1999, Maeda published *Design By Numbers* (MIT Press), which outlines the fundamental concepts from his experiments developing programming languages that engage a visual sensibility. He and his partner, Kris Maeda, run the print and digital design consultancy MAEDASTUDIO in Lexington, Massachusetts.

ANDREA MOED has written on digital design and culture for *Metropolis*, PRINT, *World Art*, *If/Then*, and other publications, and has developed Web-site content for clients such as the Brooklyn Children's Museum, the Brooklyn Museum of Art, Johnson & Johnson, and IBM. She is currently a student at New York University's Interactive Telecommunications Program, where she focuses on creating experiences at the intersection of the physical and online worlds.

RHONDA RUBINSTEIN is a creative director based in San Francisco. She has created and redesigned over a dozen magazines, as well as several Web sites, for clients such as Time Inc., Disney, Telemedia, and Condé Nast. She recently redesigned *Details* magazine, which relaunched in October 1999. Since spring 1998, she has been creative director of the political magazine, *Mother Jones*. She was brought to San Francisco in 1996 by Wired Ventures to conceive a new consumer magazine. Preceeding that, during the three years that Rubinstein was art director of *Esquire* in New York City, the magazine was acclaimed for its cover design innovations. Her work is recognized in numerous books on design including *Magazines Inside & Out*, *Becoming a Graphic Designer*, and *Covers & Jackets: What the Best-Dressed Books and Magazines are Wearing*. Rubinstein writes about media, design and popular culture for various publications including *Emigré*, PRINT, and *Saturday Night*.

CARL STEADMAN is the co-founder of *Suck* and the creator of *Placing*. A former producer for HotWired, he has written two books on Internet applications for Addison-Wesley. Steadman was named one of the "50 People Who Matter Most on the Internet" by *Newsweek*, and one of 20 "Digital Media Masters" by *Advertising Age*. Currently, he's creative director for Listen.com, the downloadable music directory, and he writes the back-page column for *The Industry Standard*, a newsweekly focused on the networked economy. His work has also appeared in *Wired*, *Spin*, and *Feed*, among other publications.

KATHERINE NELSON, editor of *Websights*, is a design writer and associate editor at PRINT magazine. Her writing has appeared in *Harper's Bazaar* and *Publisher's Weekly* among other publications. She edits "Design & New Media," a bi-monthly column appearing in PRINT.

Book designer CHRISTA SKINNER is art director of *Blue* magazine and a freelance designer whose work includes CD-ROM, packaging, and motion graphics. As senior designer at David Carson Design for the past four years, she has worked on projects for AT+T, MGM, Packard Bell, USwest, Vidal Sasson, ZooTV, Nissan as well as *Speak* and *Raygun* magazines. Her work has been featured in PRINT and *Idea* magazines and she was recently named by *Metropolis* magazine as one of the leading American designers under the age of 30 .

credits >

CHAPTER 1

Page 14. ©1995 Time, Inc. Reprinted by permission. Art directors: Milton Glaser, Walter Bernard; digital illustrator: Ron Plyman; background photographer: Joy Colton.

Page 15. Reprinted with permission from *Wired* and the following photographers: Photo of Brian Eno copyright ©1995 Steve Double, Retna Ltd. Photo of Newt Gingrich copyright ©1995 Neil Selkirk, Neil Selkirk, Inc.; art director: John Plunkett. Photo of Walter Wristen copyright ©1996 James Porto, James Porto Photographer, Inc.; art director: John Plunkett. Photo of George Gilder copyright ©1996 Jill Greenberg, Jill Greenberg Studio; designer: Thomas Schneider; photo editor: Erica Ackerberg.

Page 18. Copyright ©1998 FUNNY GARBAGE v. 20. Art director: Peter Girardi; designers/illustrators: Chris Capuozzi, Peter Girardi.

Page 19. Copyright ©1994-99 Wired Digital, Inc. All rights reserved.

Page 20. Copyright ©1999 SocioX. Art director/designer: Bridget de Socio; illustrator: Lisa Webster; digital effects: Mayra Morrison, Malcom Turk.

Page 21. Left: Copyright ©1999 Time Inc. New Media. All rights reserved. Reproduction in whole or in part without

more

credits >

Pages 162, 163. Copyright ©The Procter & Gamble Company. Used by permission.

Pages 164–167. Asolut DJ images copyright ©1998 V&S Vin & Sprit AB. Imported by the House of Seagram, New York, NY. Design firm: Red Sky Interactive; designers: Laura de Young, Rob Brown; animator: Michael Kosacki; production artists: Christina Neville, Allisia Cheuk; programmer: Jeff Miller; copywriter: Jessica Burdman; producer: StacyStevenson; creative director: Kirk Gibbons; executive producer: Pete Callaro, TBWA Chiat/Day (NYC); executive creative director: Dan Braun, TBWA Chiat/Day (NYC).

Page 168. Copyright ©iDeutsch. Senior art director: David Skokna; copy writer: Suzanne Darmory; junior art director: Darrel Gervasi; technologist: Jason Snyder; creative director: Keith Ciampa; director of interactive services: Adam Levine; media supervisor: Laura Mete; producer: Gene Liebel.

Page 169. Copyright ©1994–1999 Hewlett-Packard Company. Design firm: Red Sky Interactive; art director/illustrator: Joel Hladecek; designer: Kelly Clark; client: Hewlett-Packard.

CHAPTER 10

Pages 173, 174. Cheshire Cat, Father John illustrations courtesy Simon & Schuster Books for Young Readers, an imprint of Simon & Schuster Children's Publishing Division. From *Alice's Adventures in Wonderland* by Lewis Carroll published by the MacMillan Company, New York, 1898. [The book was first published in 1865.] Illustrations: Sir John Tenniel.

Page 176. Copyright ©I/O/D 1999. Art direction/design: I/O/D.

Page 177. Screen shot of Expedia, Inc. reprinted courtesy the Microsoft Corporation. Copyright © 1999 Microsoft Corporation. Expedia is either a registered trademark or a trademark of the Microsoft Copproration in the United States and/or other countries.

Page 178. Copyright ©1999 IDEO Product Development.

Page 179. Matthew Paris's map of Britain, circa 1250. By permission of the British Library, MS COTT CLAUD D. VI., fol 12v. Image source: Edward R. Tufte, *Visual Explanations* (Cheshire, CT: Graphics Press, 1997) 24.